LIFE
DRAWING

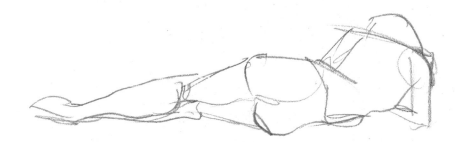

LIFE DRAWING

A COMPLETE GUIDE TO DRAWING PEOPLE

DR JENNIFER CROUCH

SIRIUS

Dr Jennifer Crouch is an artist and qualified teacher with a background in physics, technical drawing and medical illustration. She worked as a medical artist at St George's University Department of Anatomy from 2011 to 2013 and was a tutor for the Anatomical Drawing courses at Central Saint Martins from 2012 to 2018. She was awarded her PhD from the University of Portsmouth for her practice-based research on the physical phenomena used in MRI, corporeality, and the ways in which bodies and machines interface. Jennifer's art-science practice is informed by science and expressed through the fantastical synthesis of multi-sensory experiences. Her practice and research make use of drawing, technology, sculpture, weaving and painting. She is co-founder of the art-science collective Jiggling Atoms, runs public art workshops and has authored books on both drawing and popular science.

SIRIUS

This edition published in 2023 by Sirius Publishing, a division of Arcturus Publishing Limited,
26/27 Bickels Yard, 151–153 Bermondsey Street,
London SE1 3HA

ISBN: 978-1-3988-3057-8
AD010560UK

Printed in China

CONTENTS

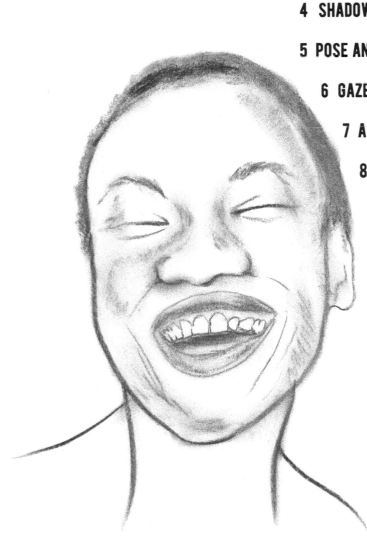

INTRODUCTION

This book focuses on some of the principles of life drawing. Using detailed step-by-step examples, I want to show how simple forms can be used to construct the figure and how detail can be gradually and cumulatively added to a drawing to create tone, textures and details that it might not be possible to capture in a life-drawing session.

I focus on the following principles of drawing:

+ **Drawing concepts**: to introduce or remind readers of perspective, and how drawing can be used as a craft that creates three-dimensional images on a two-dimensional surface.
+ **Mark-making techniques and tools**: to show how you can experiment with different drawing tools and how these drawing tools can be applied to figure drawing.
+ **Constructing the body**: the focus here is to demonstrate how drawing concepts are applied to depict the body step by step.
+ **Shadow, texture and tone**: during a sitting with a life model there may not be time to capture or depict all the details, but practising details of shadow, tone and texture could be its own project.
+ **Pose and posture**: the pose and posture of a model can be very expressive and communicate a great deal of attitude, mood and feeling in figure drawing. We show how to analyse pose and increase your sensitivity to how weight is distributed.
+ **Gaze and expression**: in a similar way to pose and posture, the direction the head is facing can indicate a lot about the attitude, mood and feelings created in a drawing. The direction of the gaze can be very powerful in an image.
+ **Activity and movement**: takes the idea of pose, posture and gaze a little bit further to explore how movement and action can be expressed in a drawing that is essentially 'still'.
+ **Details, skin and hair**: this special area of focus cannot be explored in detail in a life-drawing class, but it is nonetheless essential to developing images that show depth and personality, and are personal and intimate. It's also a fun way to 'get into' a drawing.

In some drawings you may want to emphasize some features more than others. This might include focusing on facial features and expression or posture and contour. It may also include the emphasis or simplification of textiles, objects or surroundings. With practice you will figure out what you want to draw attention to in your creations, and the stories you tell through them will emerge if you take the time to experiment and reflect on this.

It's important to mention that ethical and professional standards are important when working with a life model. Taking care of people is very important: ensuring models are warm, hydrated and feel safe. Models should not be forced to hold poses they are not comfortable with or to hold any pose for too long. Movement is important to life drawing, and as an artist you can learn to account for this. Pay models properly – above the living wage! Consent is vital in healthy relationships and this is true in life drawing too. Ask for permission to take pictures and discuss what you intend to use them for artistically.

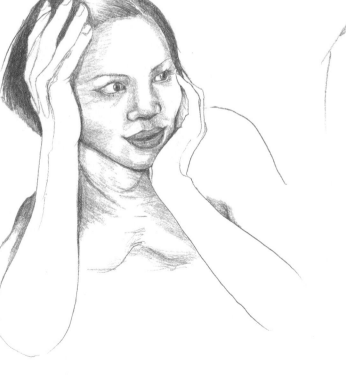

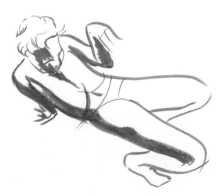

CHAPTER 1
DRAWING CONCEPTS

Ellipses are useful tools in constructing drawings that look three-dimensional. There are many fascinating things about the embodied experience of perception and the science that described the processes that are part of it. We can make use of certain shapes in our drawing to trick us into seeing three-dimensional forms and two-dimensional surfaces such as paper.

PERSPECTIVE AND ELLIPSES

perspective drawing is a specific method for drawing three-dimensional space that would require a book of its own to explain. It works by using lines to represent the horizon and to form vanishing points in order to represent the light that passes from a scene to the viewer's eye. The use of the vanishing point and understanding of perspective drawing is helpful in drawing generally.

A square seen on its side will not literally have equal sides as seen from its side. However, we can tell that what we are seeing is a square on its side. An ellipse is simply a circle seen in perspective and conforms to the same rules as a circle: it is constructed using arcs, contains no straight lines and, if divided into quarters, each resulting segment is identical.

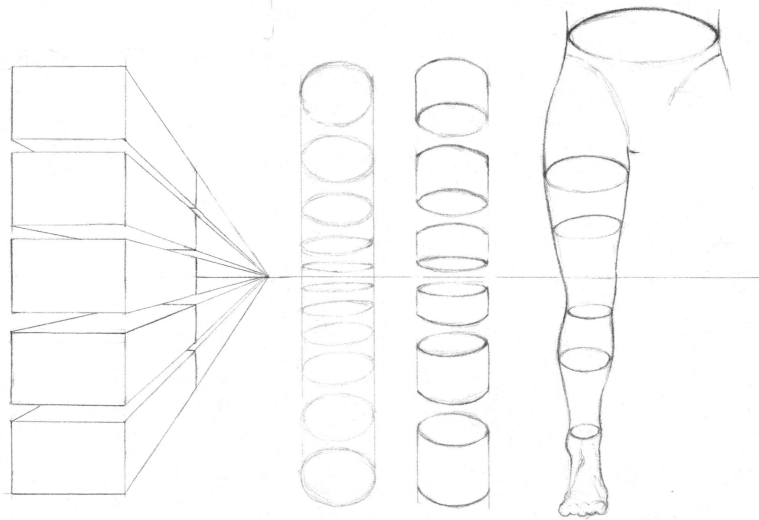

BREAKING DOWN THE BODY INTO SHAPES

If we look at representational drawing as a problem to be solved, we can break it down into smaller problems formed of cubes, cuboids, ellipses and spherical forms. An ellipse contains four identical quarters seen from an angle. We can use an ellipse to help us draw the curved forms of the body and we can imagine each segment filled with parts of a face: the ear, eye, back of the head, a glimpse of an ear. It helps us to figure out proportion and spacing, and to develop a sense of where to place eyes, brows and teeth.

The same can be said of the body itself: ellipses can be used to construct the torso, abdominal region, hips, crotch and legs. We can also achieve the same effect by using cuboids and squared shapes.

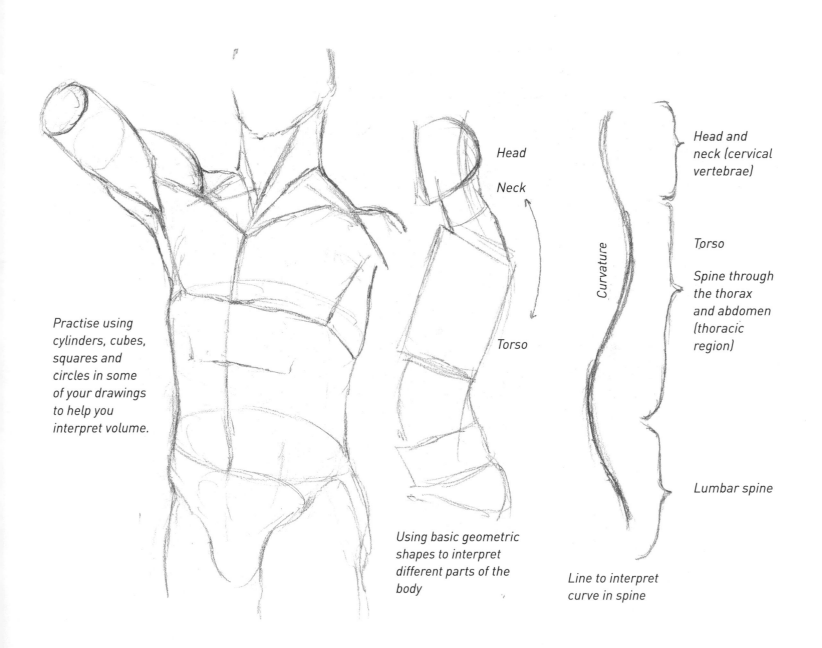

Practise using cylinders, cubes, squares and circles in some of your drawings to help you interpret volume.

Head

Neck

Torso

Using basic geometric shapes to interpret different parts of the body

Curvature

Line to interpret curve in spine

Head and neck (cervical vertebrae)

Torso

Spine through the thorax and abdomen (thoracic region)

Lumbar spine

CONSTRUCTING A FIGURE USING LINES AND ELLIPSES

There are lots of methods for constructing the figure that make use of lines, shapes, dividing lines, arcs and circles. There is no way that is intrinsically better than any other, it depends on what kind of image you want to make and what process you enjoy the most. When working with line and not 3D form, we can develop contour.

In these examples you can see how lines and ellipses are developed into a figure. The arc of the back and ellipse of the head is the starting point; introduce curved lines to represent limbs, with circles for joints.

It's all about practice, context and personal preference. I switch between different methods depending on whether I am drawing in person or from a photograph. In life-drawing classes it's nice to practise with contour, and to attempt rapid drawings that capture the form and to keep practising and practising until it feels more intuitive to you. When drawing from a photograph I find it helpful to use ellipses and cubes because the photograph itself is flat, so I almost have to 'rediscover' depth using my drawing processes.

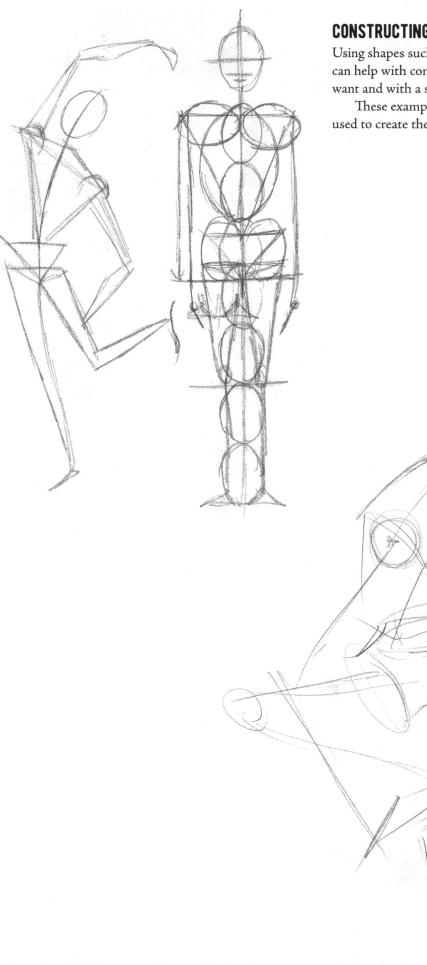

CONSTRUCTING THE FIGURE

Using shapes such as triangles, ovals, cuboids and squares can help with constructing a figure with the proportions you want and with a sense of volume and depth.

These examples demonstrate how simple shapes can be used to create the basic structure of the body.

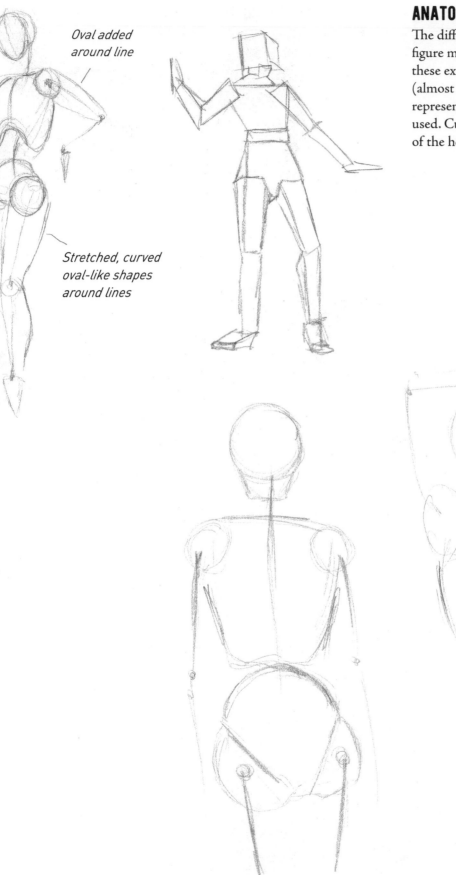

Oval added around line

Stretched, curved oval-like shapes around lines

ANATOMICAL FORMS

The different shapes you use to construct your figure may well relate to anatomical forms. In these examples a form resembling the thorax (almost a butterfly shape), circles or ovals representing the hips and a line for the spine are used. Cuboids are used to represent the volume of the head, hips, thighs, chest and feet.

3D SHAPES TO CAPTURE VOLUME

Using 3D shapes to construct the figure is a good way to learn or practise capturing the volume of the body. Familiarizing yourself with this is an interesting mental and embodied exercise that helps you create images with depth and volume. In these examples the skeletal structure itself is constructed from the inside out using ellipses.

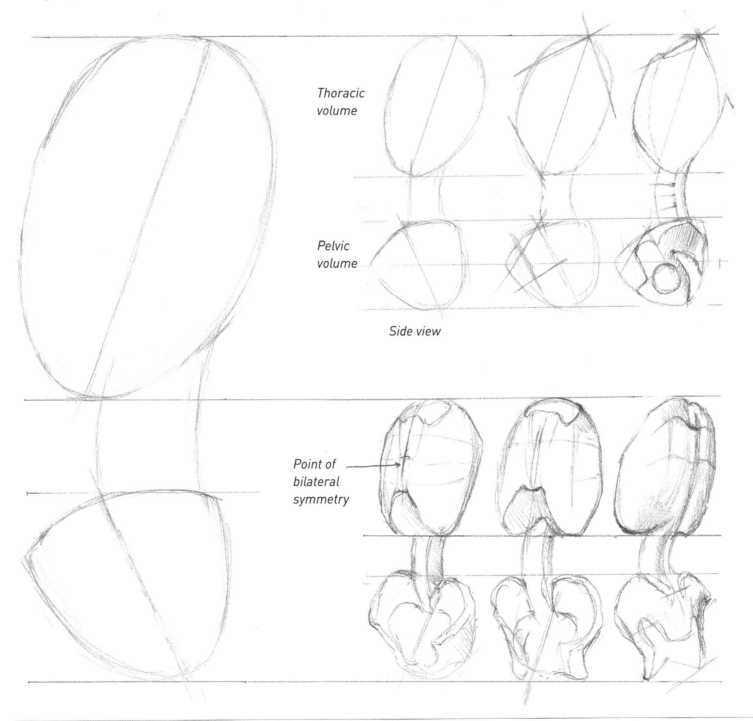

Thoracic volume

Pelvic volume

Side view

Point of bilateral symmetry

RESOLVING A DRAWING USING SHAPES

Ball and egg shapes are used for the head; cubes and cuboids connected by curved lines for the structure of the body. I usually switch between whichever technique works best to help 'resolve' a drawing. If the light is quite flat and there is a twist to the spine, or it is otherwise quite a complex pose, I tend to opt for the cube approach as it helps me square off where different parts of the body are.

Try using cuboid shapes for the hand, digits and palm. Emphasizing knuckles and other body structures and tendons using shading and rounded or elongated shapes can also help to create a very convincing image.

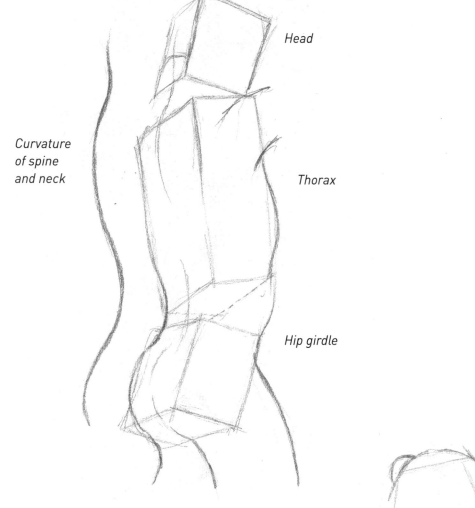

Head

Curvature
of spine
and neck

Thorax

Hip girdle

Ball and egg
shapes used to
create the head

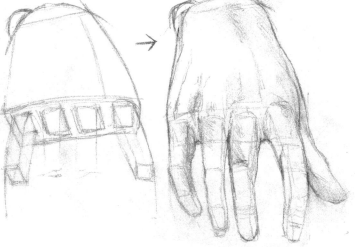

Using cuboid
shapes for hands
and fingers

USING A MANNEQUIN

A mannequin can be helpful when trying to draw a specific pose you are struggling to capture. However, drawings created using a mannequin can seem quite rigid. Something else to be aware of, other than the fact that humans are squishy, is that imagining the 'direction of a pose', i.e. where the weight is angled in different parts of the body, helps us to draw figures with more flow. To do this, imagine the shoulder and hip tilt.

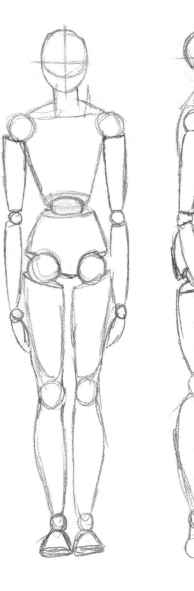

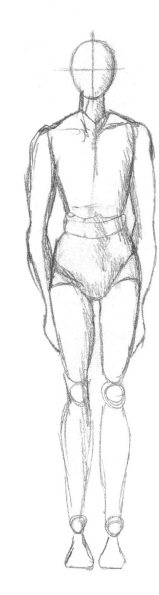

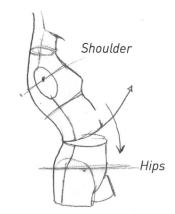

Visualize where in the figure the weight is being held.

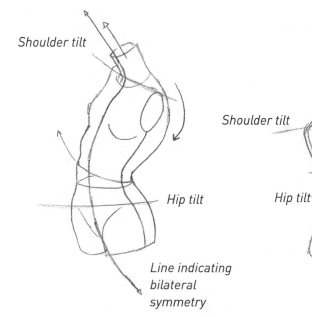

Shoulder tilt

Hip tilt

Line indicating bilateral symmetry

Shoulder tilt

Hip tilt

Shoulder

Hips

Shoulder

Hips

MANAGING PROPORTION USING CUBOIDS

In these examples the skull and a foreshortened body are sketched in cuboids drawn in perspective to help manage proportions and structure.

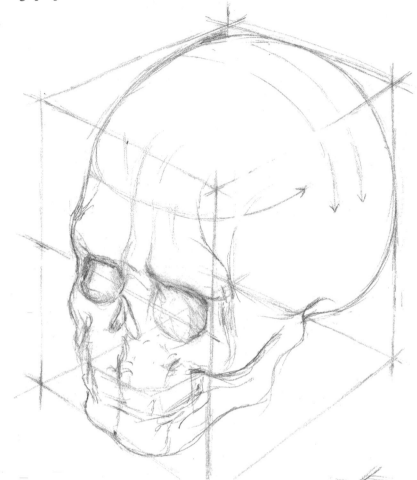

If you look down at someone's head, the parts closest to you will appear slightly longer. Your seated or standing position is as important as your model's and must be able to incorporate flexibility. Photographs can be used as references to get back into position.

Foreshortening
Using perspective can help with 'foreshortening' when the head, feet or other parts of the body are positioned in the foreground.

In the foreshortened figure, the proportions seem distorted: things in the foreground look enlarged while structures in the distance look strangely small.

DRAWING THE HEAD

When the head is drawn as an egg and ball, the shapes can also be divided up to help place the facial features so that they match those of the model.

A central vertical line halfway across the egg shape that goes straight down indicates a line of symmetry, known as bilateral symmetry, which is the same as mirror symmetry. On either side of this line, you can place the features.

A horizontal line across the middle of the egg shape, halfway down, is where the eyes can be drawn. This line tends to correspond with the point where the ears protrude from the head. By dividing the head into halves and quarters you can map out the proportions of the person who is sitting for you.

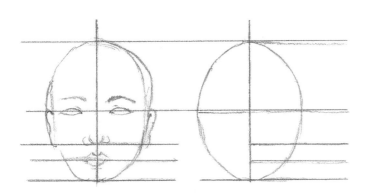

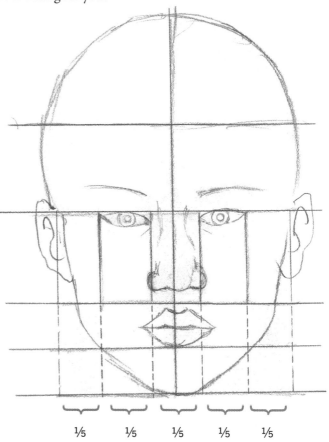

⅕ ⅕ ⅕ ⅕ ⅕

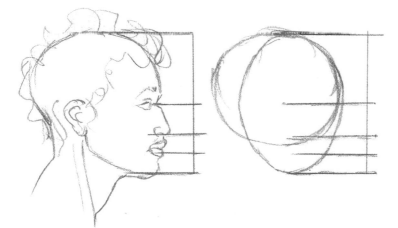

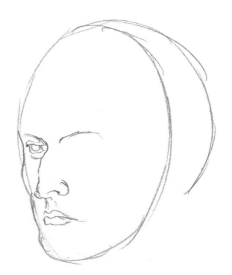

THE TILT OF THE HEAD

The tilt of the head is an important feature to work on as it informs much of the pose, posture and gaze of the figure. When you draw the egg and ball shapes, drawing a line in the centre of the egg shape will help you interpret where the line of bilateral symmetry on the face of your model is, i.e. which way they are facing. Sketch this first, followed by an ellipse halfway down the egg shape perpendicular to the line of bilateral symmetry – this is the eye line. Construct the rest of the head and features in relation to these two lines.

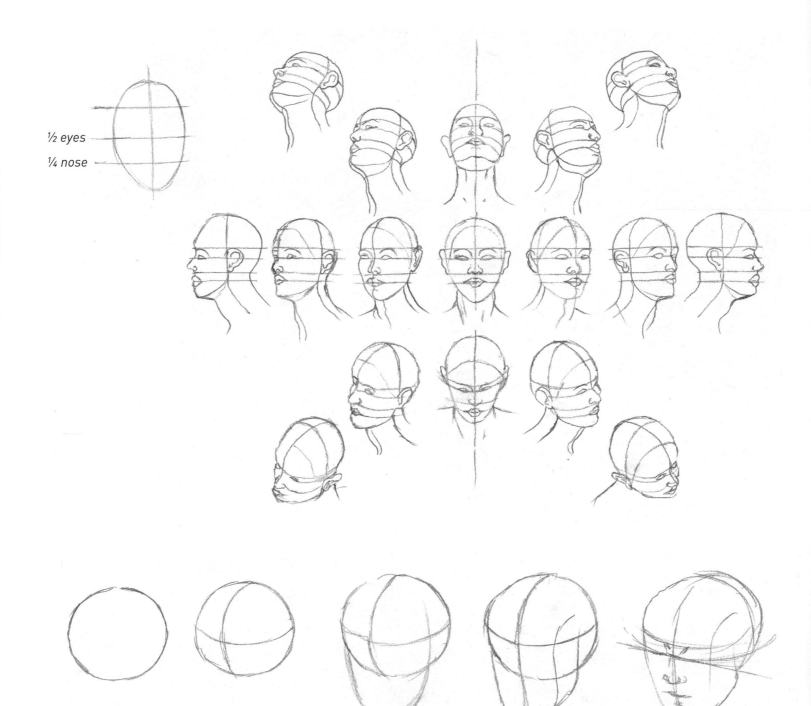

½ eyes

¼ nose

MOVING FROM CUBOIDS TO CONTOUR

The construction of a reclining figure with a twist in the spine can be quite complex. Lightly sketching cubed shapes (or blocks) can help you to deconstruct and reconstruct what you observe, and orientate different parts of the body. Try to observe the tilt of the head as it relates to the directions in which the torso, hips and legs are facing.

These shapes don't have to be precise or exact, they just have to guide you to think about where different parts of the body are facing. Lightly sketch the side of the torso, front and back (the front is obscured from our view in this image). Lightly sketch the hips as if they were a kind of cubed shape, the legs as oblong shapes. Using contours, you can then 'sculpt' into these blocks, with ever-increasing accuracy, using curved lines and adding creases in the neck. If you sketch the initial blocks very lightly you can easily erase them with a putty rubber.

In this pose the figure is on the floor, with their shoulders twisted towards us as a three-quarter turn. One leg is folded under the other and the hands are pushing against the floor, supporting the pose. It's quite a natural pose,

When constructing a scene with multiple people, use the same technique with blocks and shapes. You will need to be careful with perspective when drawing groups. Experiment by drawing a group around a square or rectangular table which you can use to help with measurement and proportions in your drawing.

QUICK SKETCHES

These drawings were developed using an HB pencil and carried out as quick studies. They are somewhere in between a sketch created with blocks and a contour drawing. Varying the degree of contour and the amount of blocks you use in your drawing process is up to you, they are simply tools that can be used in drawings. There are many other methods you can use that focus more on anatomy and on contour.

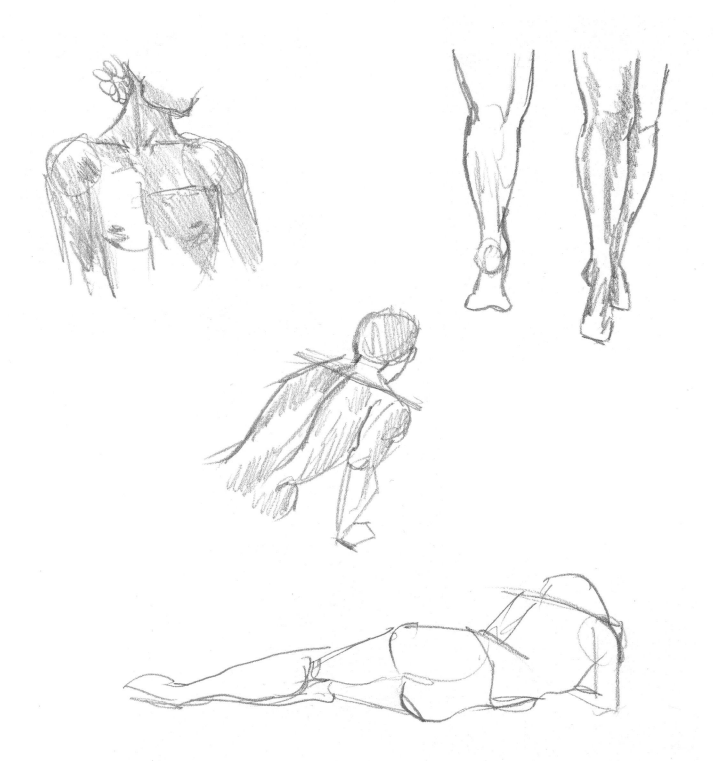

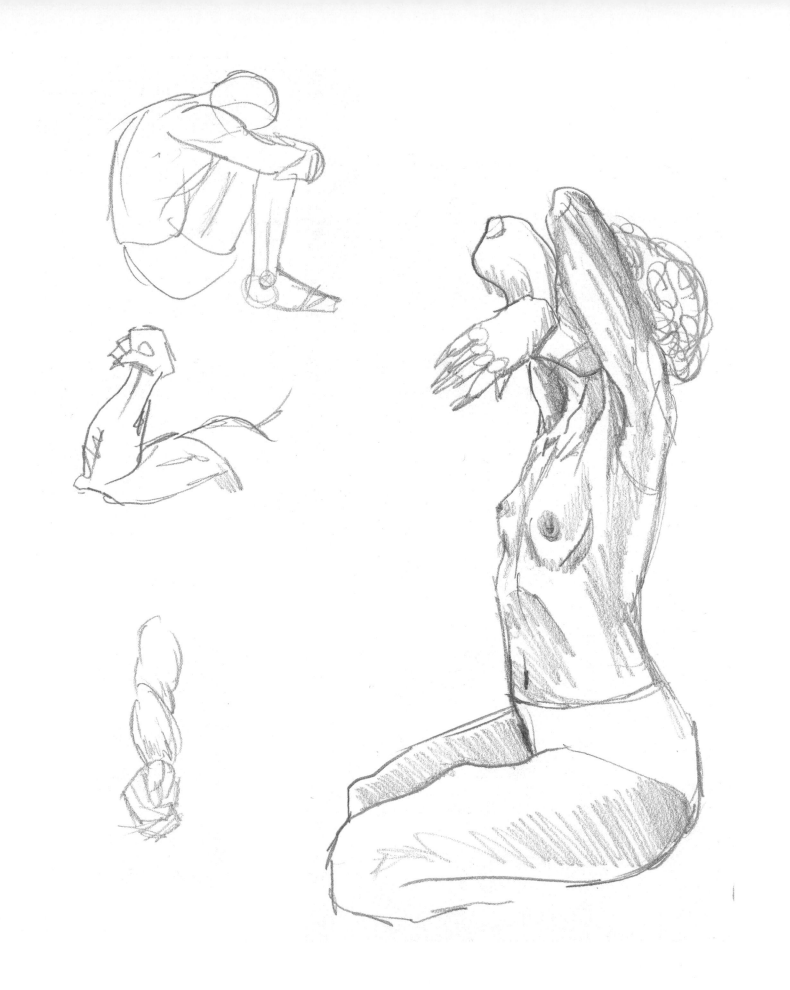

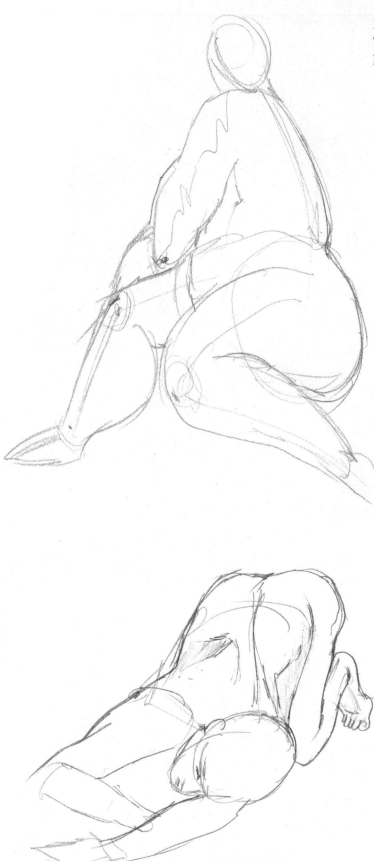

In these drawings three figures have been drawn in contour. Try to find easy-to-identify shapes in the contour: curved lines in the shape of 's', 'c', 'n' or 'm'.

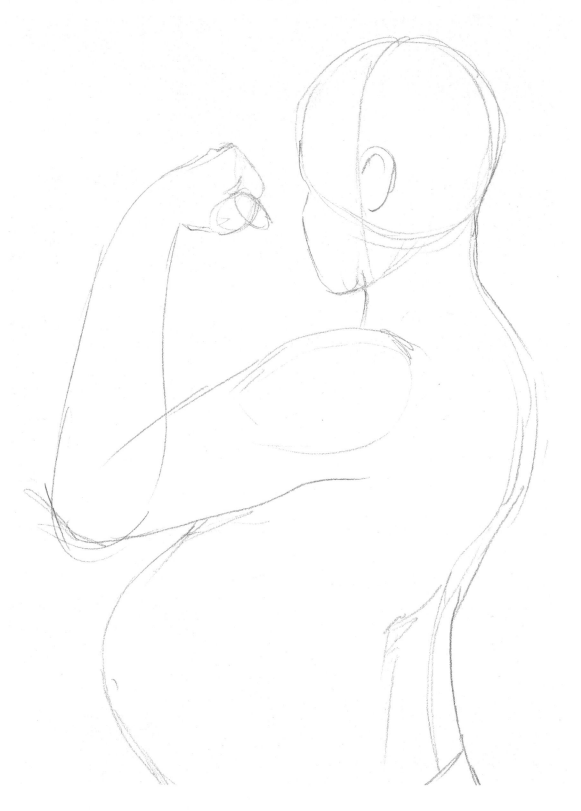

In this drawing mainly the curvature of the spine was emphasized using a curved line. The use of 's'- and 'c'-shaped lines can be very useful in life drawing. The spine in this image follows a simple but stretched-out 's' shape. C shapes are also useful in creating contour. Curved lines and forms such as these will be referred to throughout the other chapters.

MARK-MAKING TECHNIQUES AND TOOLS

Drawing tools are very varied and can be substituted and adapted. Practising drawing in different materials is a good way to learn how to loosen up or give up the control which you may have with a more familiar drawing tool.

Charcoal, pencil, graphite, ink and wash, oil pastels, oil bar and chalks are all great to work with.

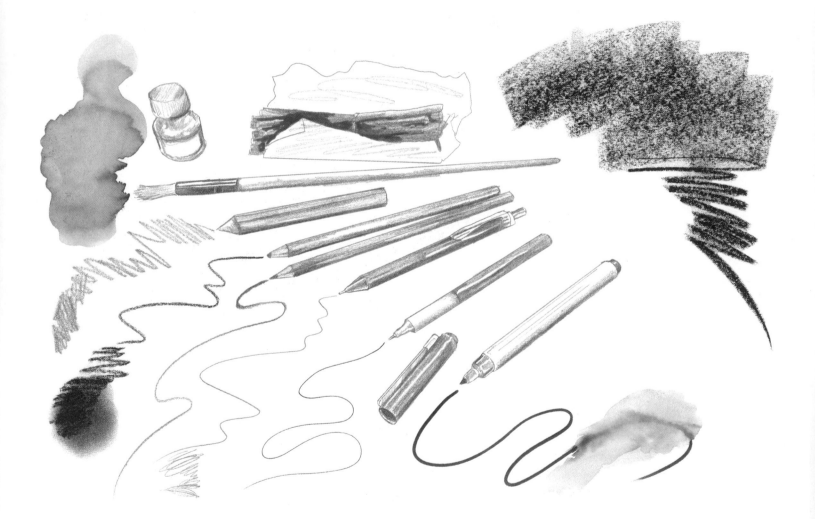

TONAL LADDERS

Hatching, cross hatching, stippling and circular scribbles are all types of mark making that can be used to create textures seen in the figure. Experiment freely with each of these techniques; try covering a page with a combination of all of them. Try to create a tonal ladder using each technique.

Hatching and cross hatching can be used together in figure drawing. Stippling and circular scribbles are useful for creating the texture of hair.

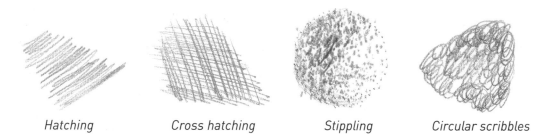

Hatching *Cross hatching* *Stippling* *Circular scribbles*

Hatching: *the use of fine, parallel lines close together.*

Cross hatching: *an extension of hatching which uses parallel lines crossing over each other at an angle.*

Stippling: *a drawing technique that uses nothing but dots.*

Charcoal blend: *uses a piece of paper or tissue to blend from dark to light.*

Random marks: *depict light or shadow, using random lines, marks or scribbles.*

Circular scribbles: *a useful method for creating texture and tone.*

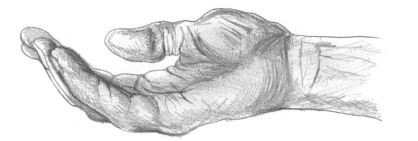

MARK-MAKING TECHNIQUES

In this example you can see how different pencil weights and mark-making techniques can be applied to the figure. This example looks specifically at hair.

Line weight is simply the intensity or thickness of the line you draw. Lines can be feather-light or heavy. For a heavy line weight, I recommend not pressing very hard right away but gradually building up tone and pressure on the line or area of line you want to emphasize. Darker or lighter lines can be used in drawing hair and capturing different hair textures. Varying the line weight can also be used to create depth: in terms of contour a darker line can be used to show an area of shadow or the structure of the figure that is in the foreground.

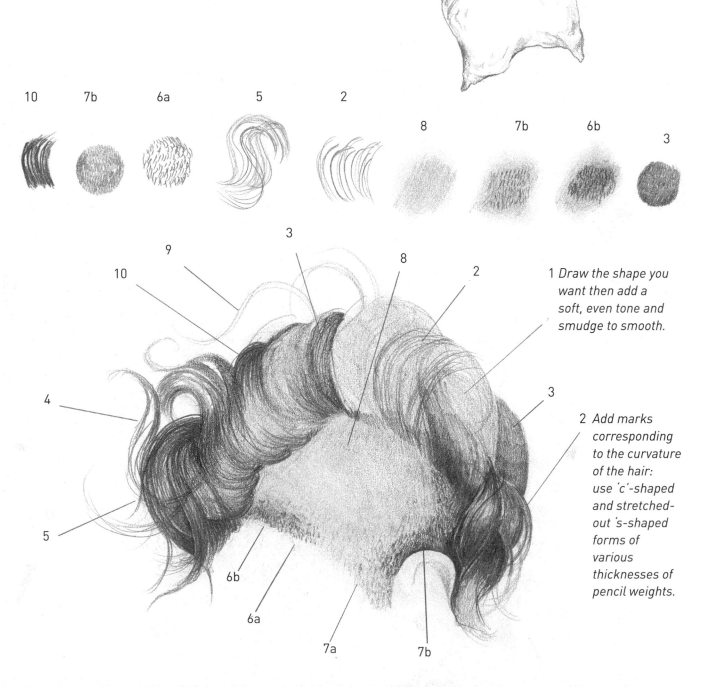

1 *Draw the shape you want then add a soft, even tone and smudge to smooth.*

2 *Add marks corresponding to the curvature of the hair: use 'c'-shaped and stretched-out 's-shaped forms of various thicknesses of pencil weights.*

EXPERIMENTS WITH GRAPHITE AND MARK MAKING.

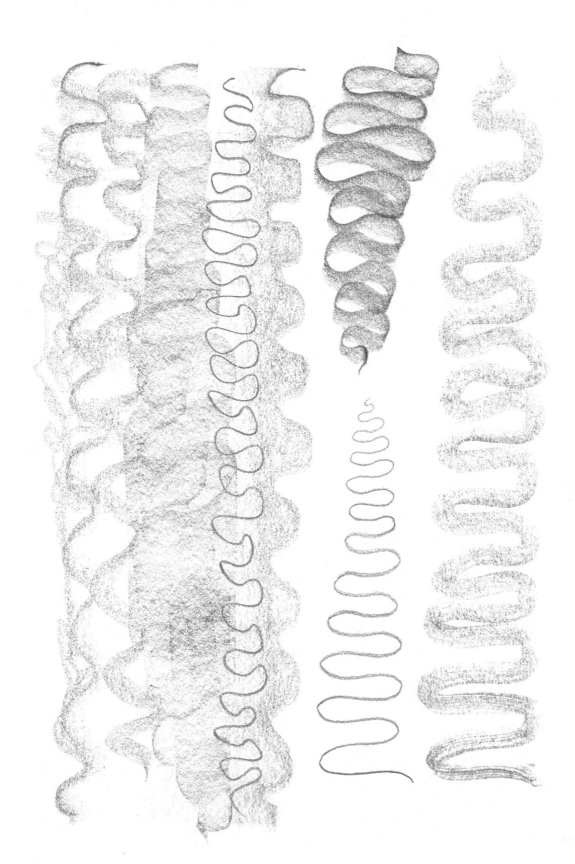

MARK MAKING WITH CHARCOAL

The focus of this book is pencil, but it's worth mentioning charcoal in case you want to experiment with it. Charcoal can be applied with the hands or even a brush for extra precision. In life drawing it is very often used for quick studies of the figure. Incorporating experimentation with making marks into your practice using charcoal – smudging it, stippling or rubbing it on its side over a textured surface – will help you familiarize yourself with its potential.

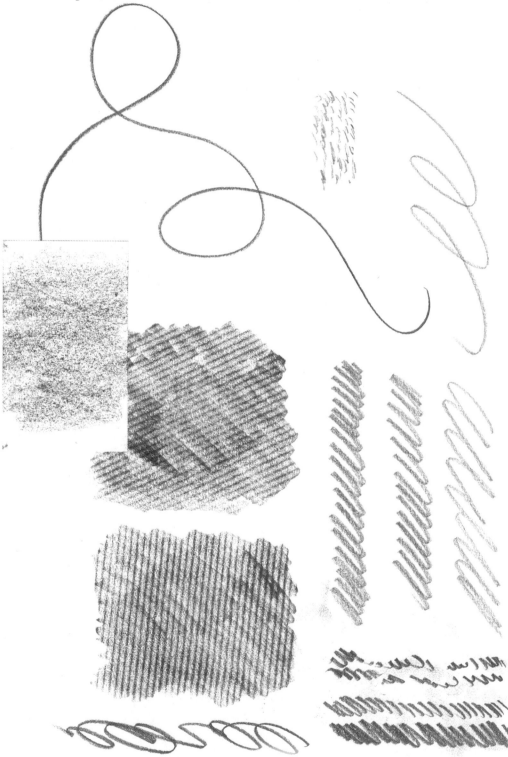

EXPERIMENTS WITH CHARCOAL AND MARK MAKING

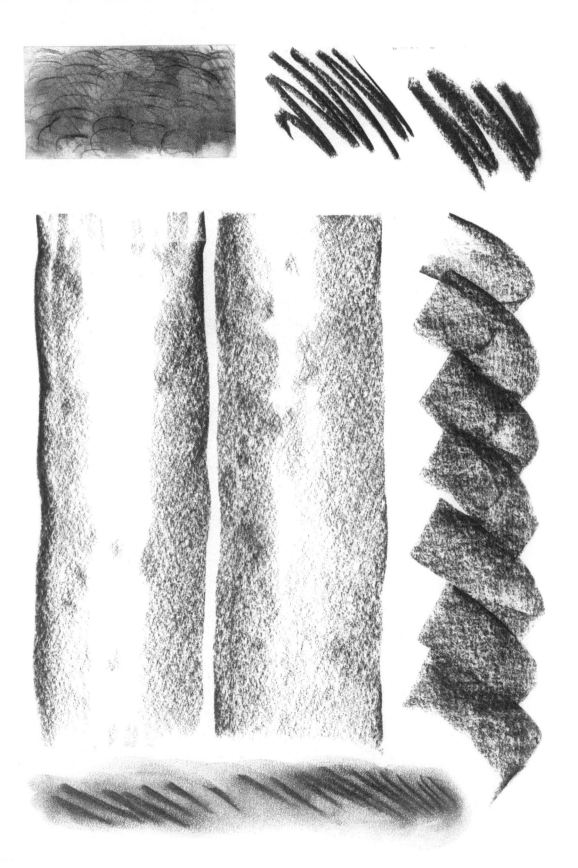

INK WASH AND TONAL LADDERS

Creating a tonal ladder with ink and wash, ink and mark making is also worth experimenting with to encourage you to do figure drawings in ink.

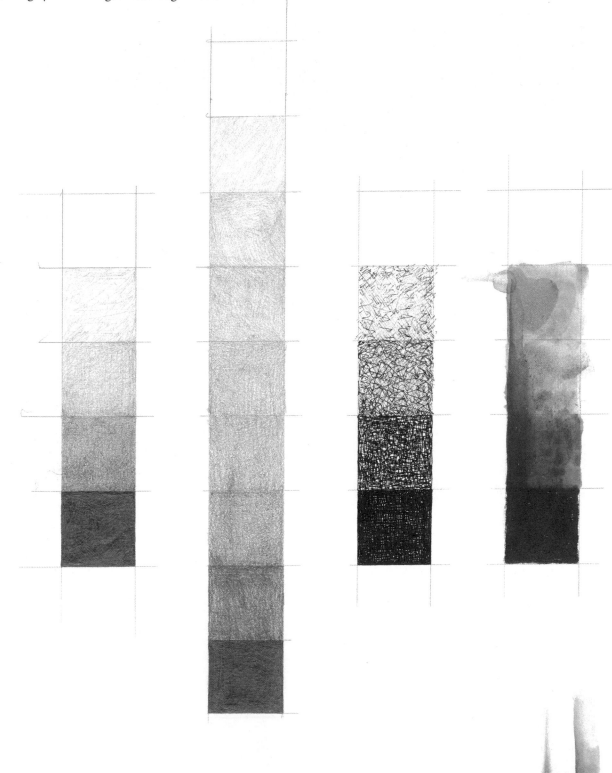

INK EXPERIMENTS

Using a brush or the end of a brush, you can create cross-hatched textures.

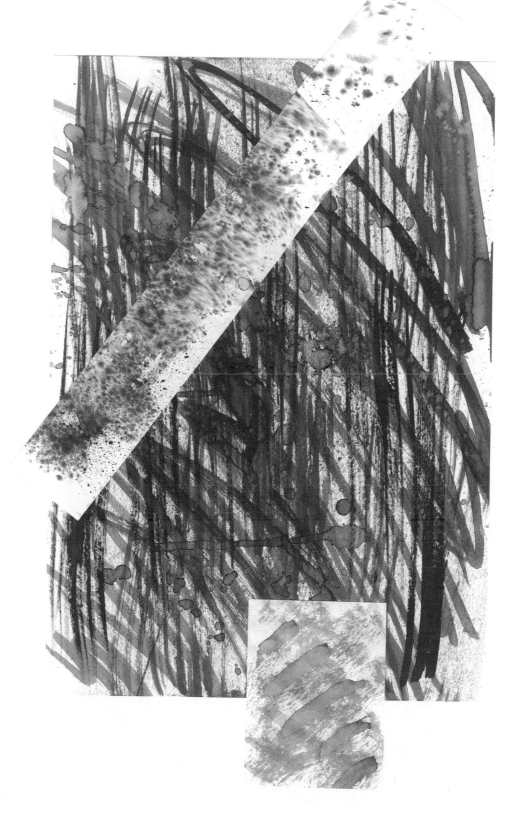

EXPRESSION WITH INK

Ink can be used in a very expressive way. You can use water and splatters to experiment with different effects that can then be applied to figure drawing. The movement, flow and splatters of the ink can be used to create very lively and expressive movements in figure drawing.

Experiment with wet paper and dry paper, with stippling and splattering, using a hard, dry brush or an old toothbrush.

You can be very creative with ink and experiment with some gorgeous and surprising textures on dry or wet paper, using splashes or marks, watered-down ink, a very dry brush or just different combinations on different bits of paper. Collage them together when they are dry.

GRAPHITE AND PENCIL

Graphite is basically pencil, except that a graphite
stick is like a large stick of pencil lead. It can be used
in numerous ways.

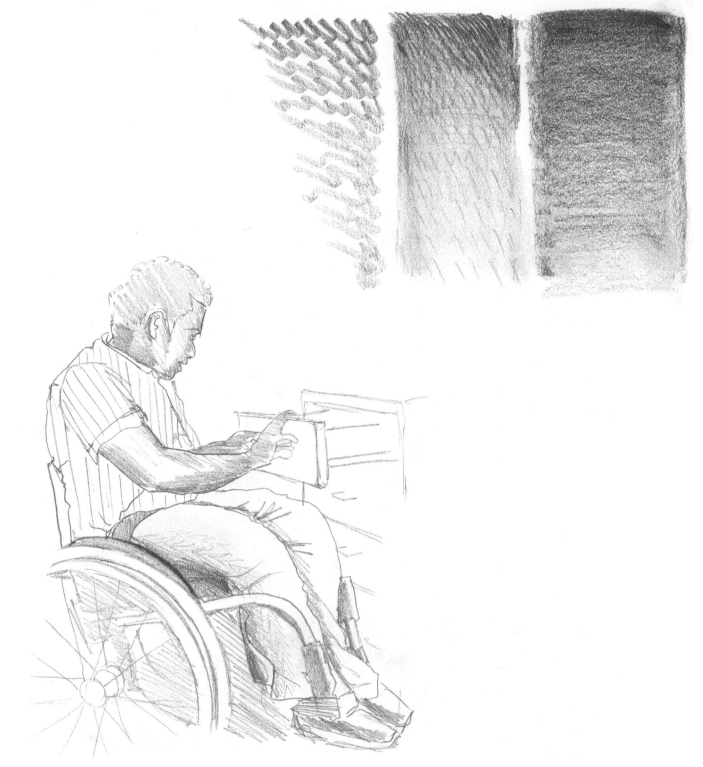

MARK MAKING AND FIGURE DRAWING

In this drawing mainly line and contour are used. Mark making is very useful in creating various textures such as the different line weights used for the hair.

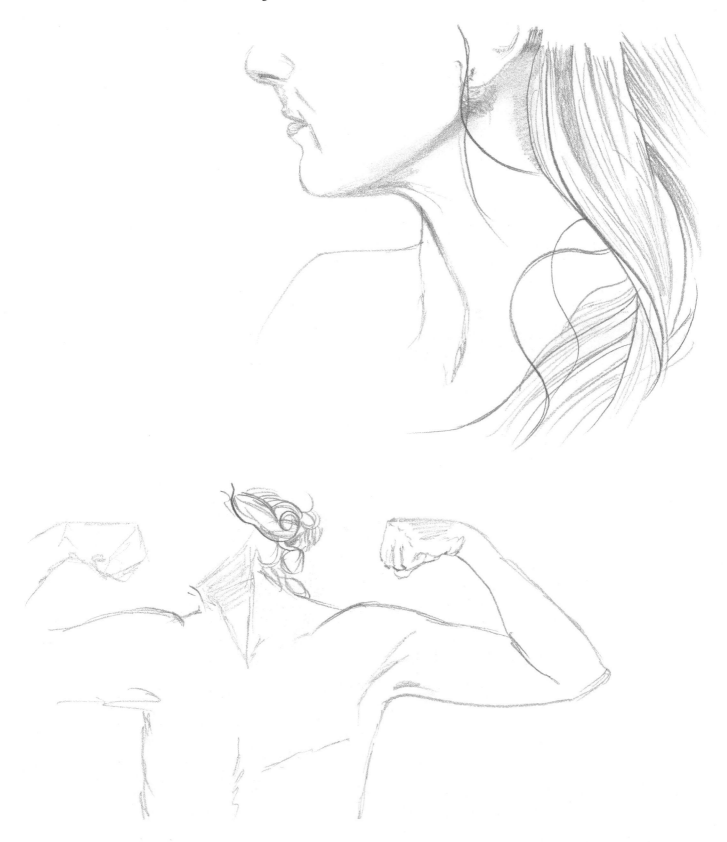

BUILDING TONE AND TEXTURE

Use mark making incrementally to gradually build up tone and texture. Blend using a blending tool (these can be purchased or made) or by using a tissue or your finger. Blending can be achieved by using a hard 8H pencil lightly hatched or shaded in a light circular motion. Some teachers do not recommend using your finger to blend as it can make the page oily, while some people also don't like getting graphite on their finger as it can spread across the page. I personally find it quite tactile and convenient – we each have our own preferences that we discover and adapt as we learn.

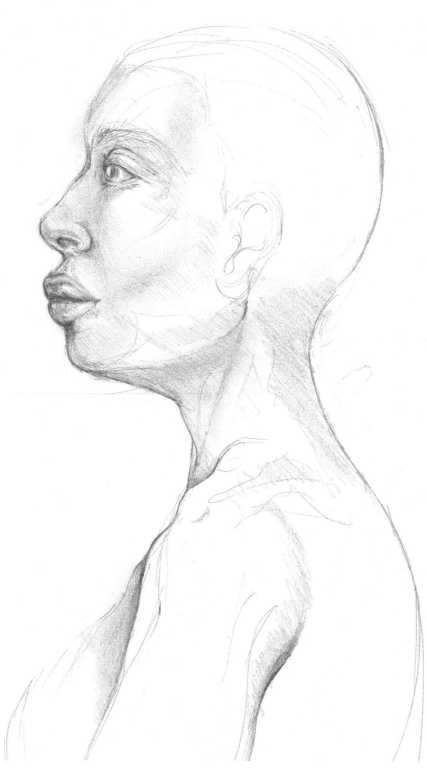

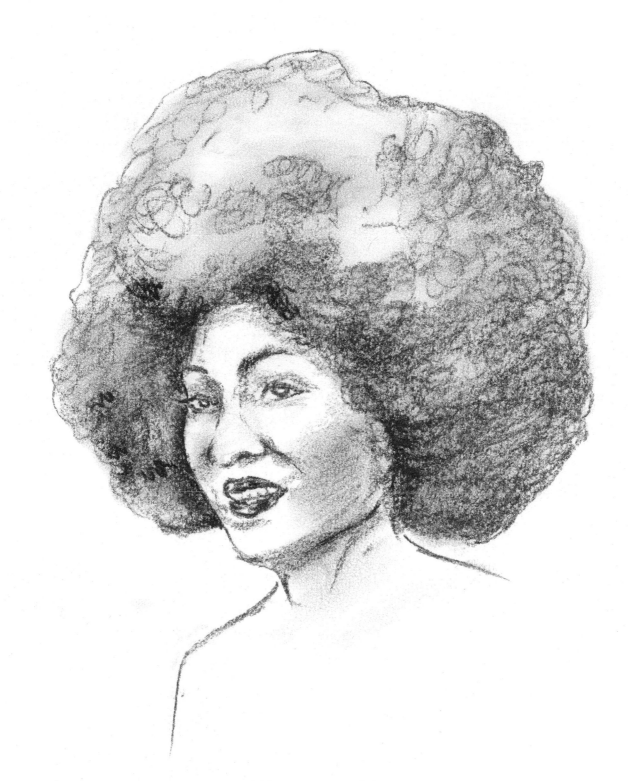

USING CHARCOAL

Gradually building tone in charcoal can be very effective as it is easily blended. Try to use a charcoal pencil if you can, as these can be sharpened to a point and enable you to draw in more detail.

These drawings use charcoal sticks to capture contour. Some areas of mark making in the hair and blending to create shadows have also been used.

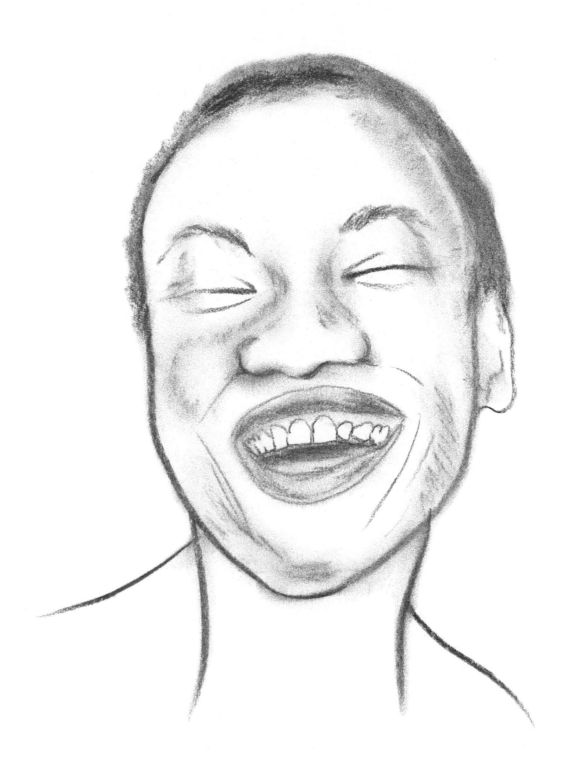

This drawing was created using charcoal stick. Contour, smudging and blending and mark making have been used. There are many ways to use charcoal: some artists use a brush to apply it in some parts of their drawings and it is possible to be very creative with its use.

SHADOWY CHARCOAL

You can create a bold and moody image by smudging charcoal into the face and then going over this with some slight marks that indicate shadows on the face. It celebrates and makes use of the messiness of smudging. Drawings don't have to be clinically clean, with neatly placed lines. Try smudging on purpose when you draw the figure: smudge across the face and outside the lines.

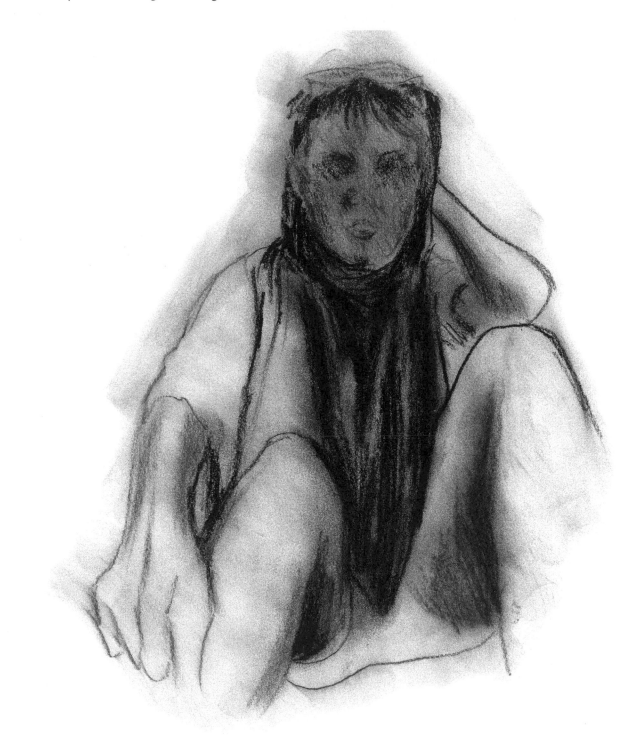

CHALK AND CHARCOAL ON BLACK PAPER

Chalk can be treated in a similar way to charcoal. It has a slightly different density but that makes it possible to use it a bit like a graphite stick. Smudging chalk images on black paper and using charcoal for the brows, eyes, hair, nostrils, mouth and shoulders (that can barely be seen) will encourage you to experiment with your use of tools. You could do this on paper of any dark colour. Using smudges makes the image look expressive and moody.

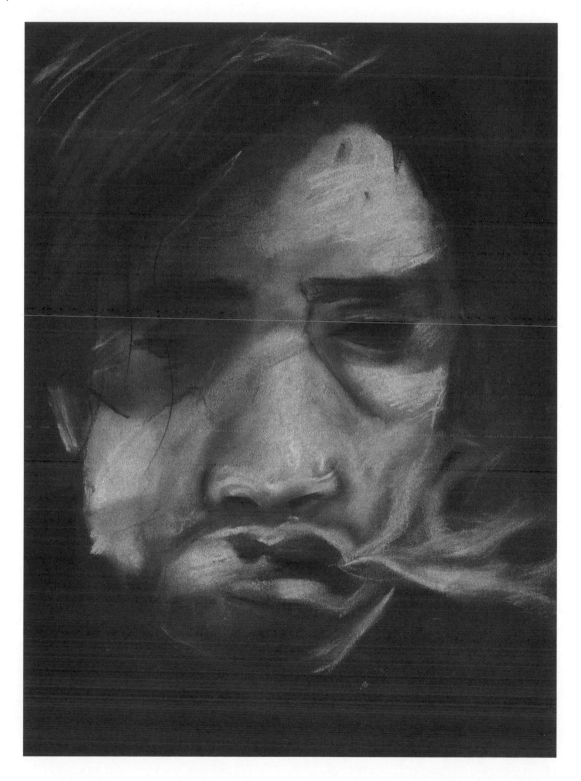

PENCIL PORTRAIT

There are many examples of portraits in this book. Try looking closely at each one to analyse where contour, structures, hatching, cross hatching and stippling have been used. This partially completed image shows how the hair is completed and how simple shapes are used to create the hair.

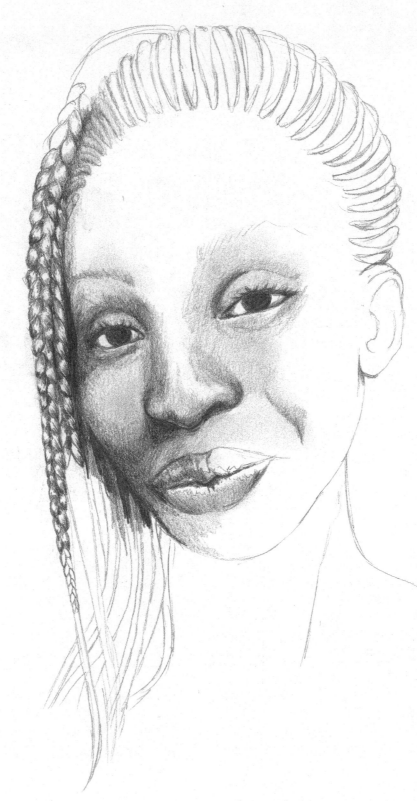

CONTOUR INK DRAWING

With practice you will develop your own approach to capturing a figure or creating a portrait. Using ink makes you take risks, and creating ink drawings from drawings you have created in pencil can build confidence in its use as you then have experience in drawing that image in a different medium.

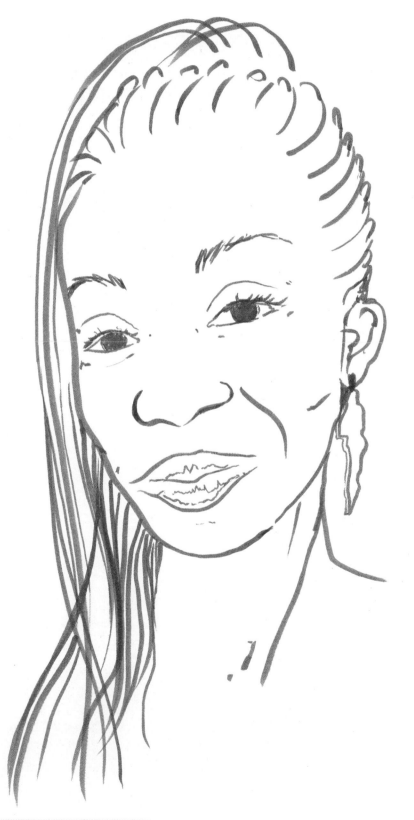

CONTOUR

Contour alone can be used to construct the figure. It is useful to practise numerous techniques and not be focused on just one. Contour can be a very effective method for capturing the external form of the figure; it can also be a useful method for becoming freer and looser with your drawing. Not everything has to be totally realistic, that is its own specialist type of image making. Drawing in a continuous line, broken line or contour is a wonderful way to focus on character, expression and movement in a drawing. As contour can be added swiftly, it's a good method for developing the muscle memory in your arm, shoulder and hand and creating more confident, less stuffy figures.

Try creating 20 quick five-minute and 20 ten-minute contour drawings. It doesn't matter if you are not happy with them, just go for it. Eventually the flow of your line will become more intentional. Try to resist the urge to create a sketched line, use a sketched line for something else. Practise simply drawing with a single confident line. The intention and direction of your line will develop the more you try this.

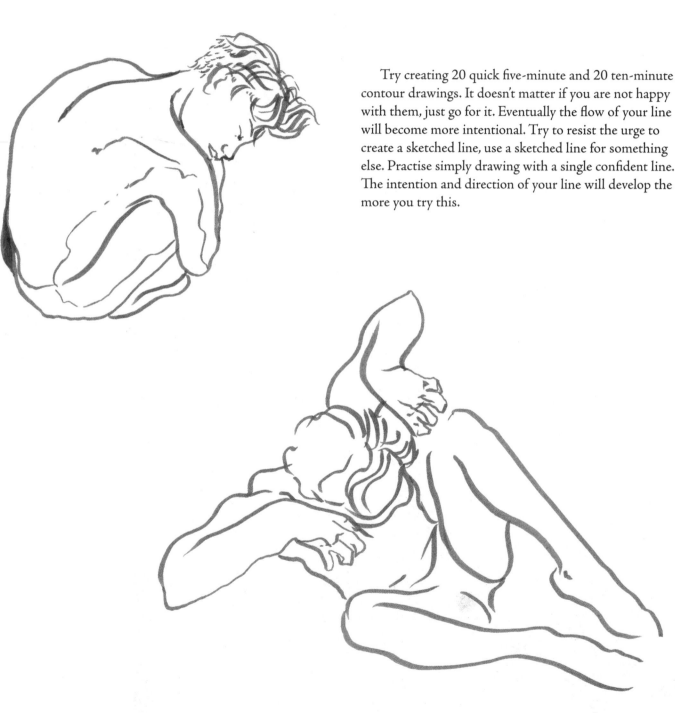

QUICK STUDY: TONE AND SHADING

Try creating the same drawing using different media. In these drawings ink and wash has been used in one, and a simple HB pencil has been used in the other with sketchy hatching used for the shadow.

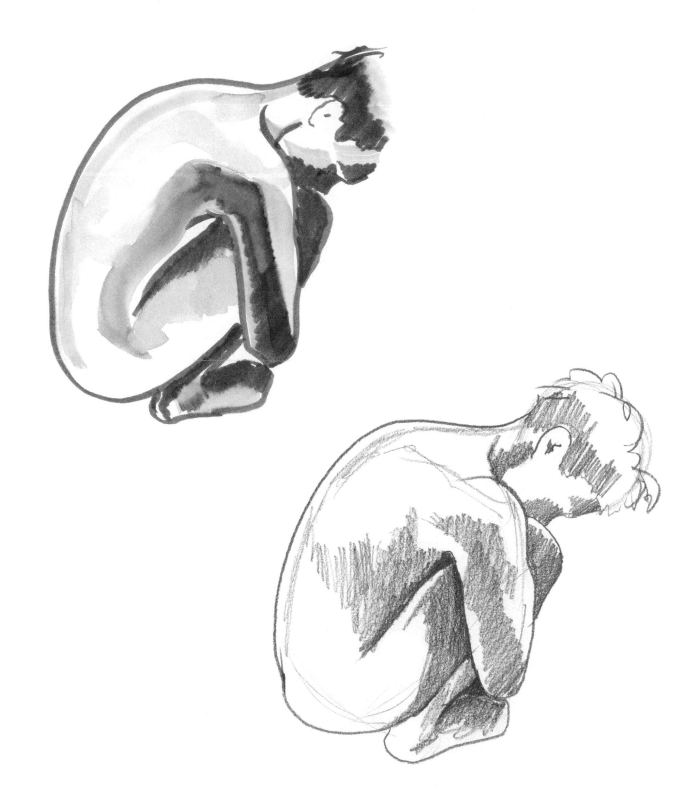

INK EXPERIMENTS

Experiment by creating partial drawing of faces and the body.

Expand your application of mark making by using splashes, splatters and water in your ink studies.

QUICK AND SLOW STUDIES

Quick and slow studies of contour are needed to develop the movements your arm and hand carry out in creating an image. Both are necessary. Don't be put off if things 'don't look right'. Just try to create images regularly; even try to do a quick contour study every day in a small, dedicated sketchbook. Be quite strict with yourself not to stray away from it just being contour and (for insurance) only taking three to five minutes. You will notice how your drawing changes over time and how your style and observations evolve.

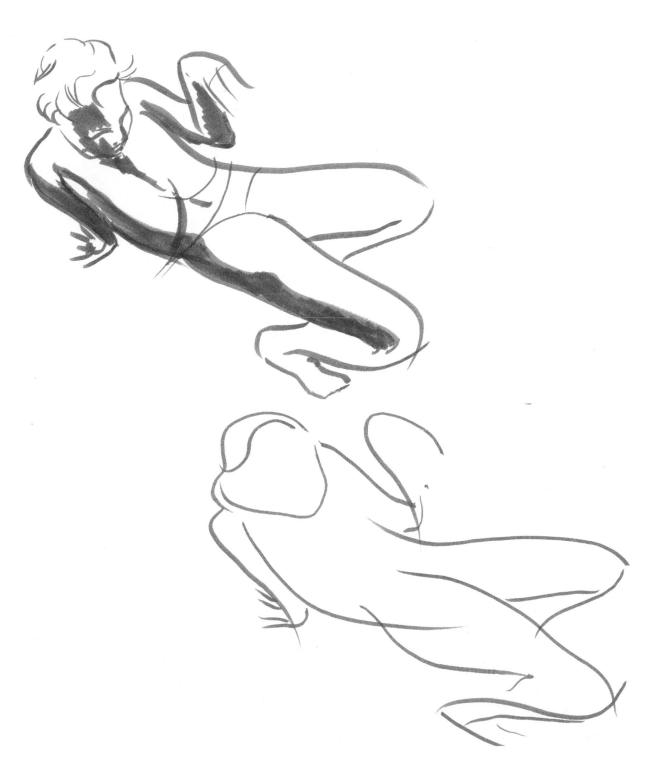

Practise drawing curved or wavy lines, marks, dots and dashes alongside your contour drawings.

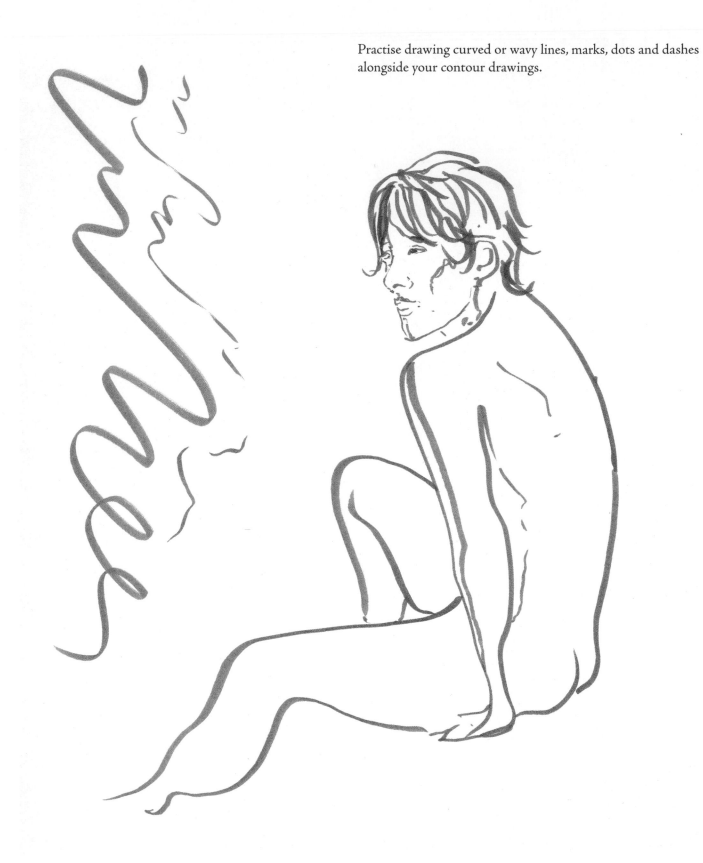

Mark-making experiments alongside a figure drawing.

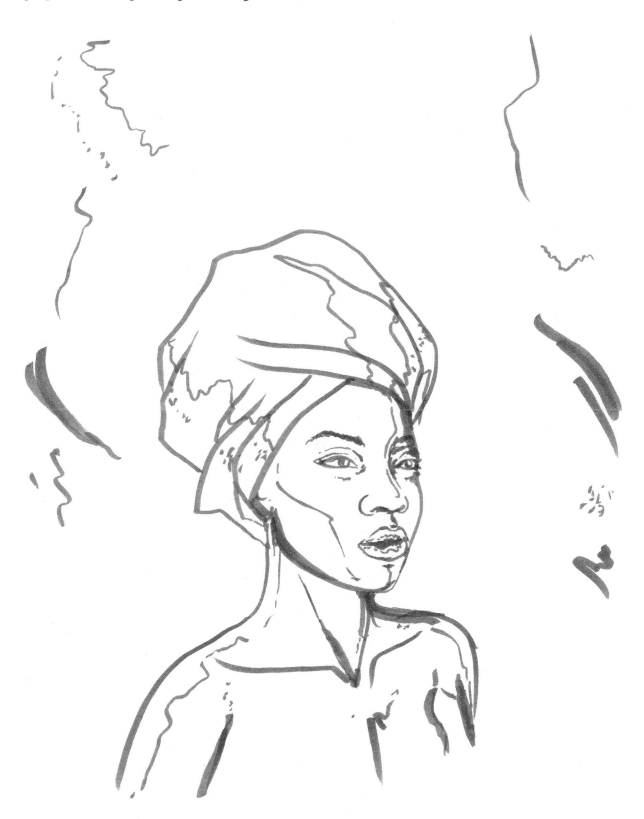

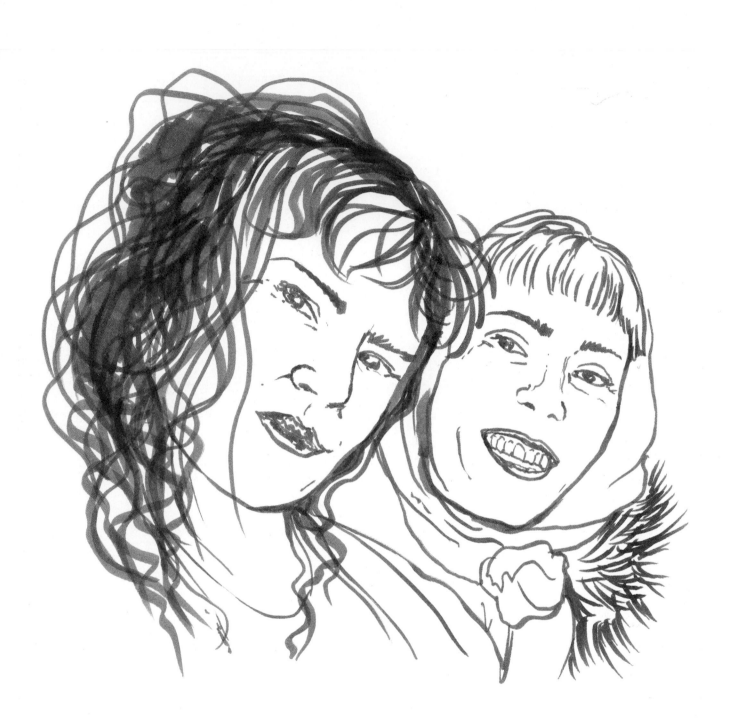

You may like to experiment with the marks you use in ink using a brush or brush pen.
This study was created from a photo and uses an ink brush.

Not all areas of the drawing need to be equally detailed. The hand in this study is very light on details, as is the hat. There are more details in the face, hair and jacket. The simplicity elsewhere draws attention to these areas.

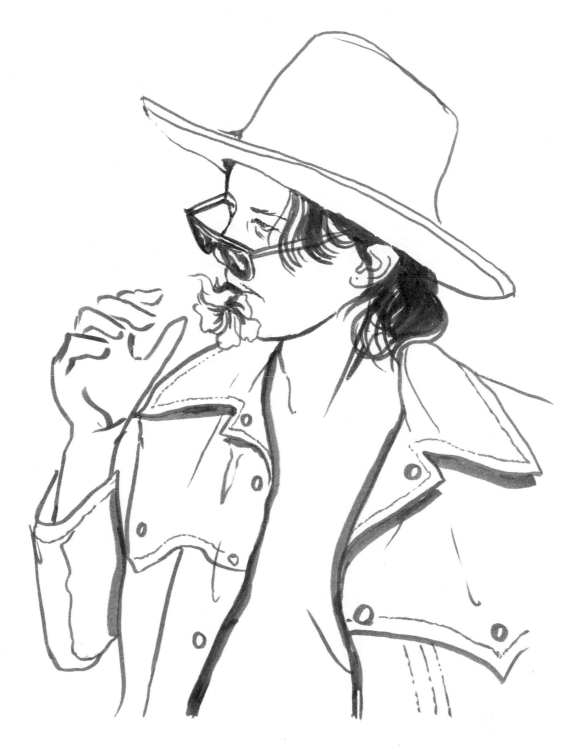

CHAPTER 3
CONSTRUCTING THE BODY

This chapter looks in more detail at the particular techniques used to create the different parts of the body. We start with the head and face, including the facial features, then move on through the arms and torso to the legs and feet.

CONSTRUCTING THE HEAD

Constructing the head using the egg and ball technique you see illustrated here is an effective way to capture the volume of the head, even when you cannot see part of it, or when it is facing straight on.

You can overlap the egg shape on top of the ball shape depending on the direction of the gaze which guides the front of the face toward, away, up, down or at an angle from the front.

Sketching out a central line to mark a line of bilateral symmetry is a good way to start mapping out facial features. Everyone is different so attend to each individual's balances and imbalances using lines. Just base what you draw on what you see. Sketch the bilateral symmetry line directly where the gaze is facing: between where the brows and eyes will be down the centre of the egg shape (face).

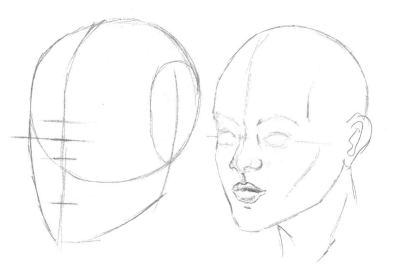

Perpendicular to this, draw another ellipse or line in the centre of the egg shape for the eyes, above this for the brows. In the lower half of the egg shape place an ellipse on which you can sketch the nose, and in which the lower quarter the mouth can be sketched. These can be considered in 'half sections'.

+ Halfway down the head sketch the 'eye line'.
+ Divide the lower half of the egg shape in half again for the nose.
+ In the lower part of this half add a line for the mouth.

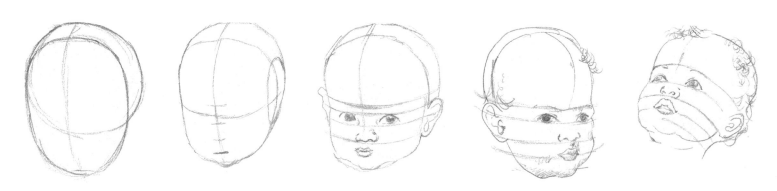

Carving features in and out of the egg and ball shape enables you to refine your drawing. Drawing is often a back and forth using a putty rubber and line, depending on whether you are focusing on the face or the whole body.

The eye line lines up with the point at which the ear is attached to the head. This is actually how glasses work.

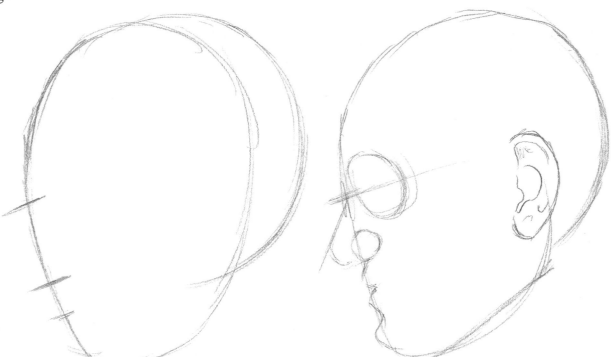

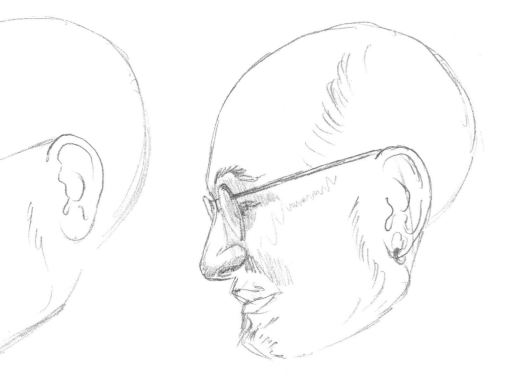

CONSTRUCTING THE EYE

The eye can be constructed from circles within circles. The central circle is the pupil, which indicates the direction of the model's gaze in most cases. The pupil can be placed *on* the ellipse in the middle of the egg shape which corresponds to the 'eye line'.

Around the pupil there is another circle that represents the iris, and another one around this that indicates the edge of the eyeball. Add curved lines to represent the eyelids. The curved lines represent the folds and edge of the eyelids. These need to be positioned across the outer circle (eyeball). Try to visualize that you are placing the eyeline *over* a spherical object even if it is a flat drawing. The eyelid may overlap the iris, but in most instances it does not overlap the pupil. Observe your model carefully: does their eyelid cover any part of the pupil?

In these drawings you can see step by step how the eye is formed from simple circles. Hatching can be used to shade around the folds of the eyelid. Add shading to the white of the eye as well. Remember that the eyeball is a spherical structure in an eye socket, protected by lids and lashes, and always has some shadow on its surface.

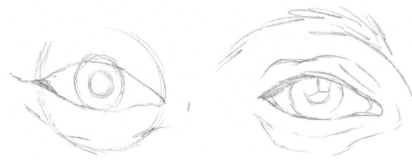

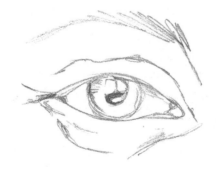

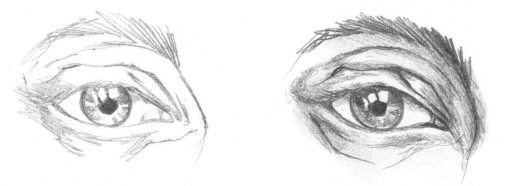

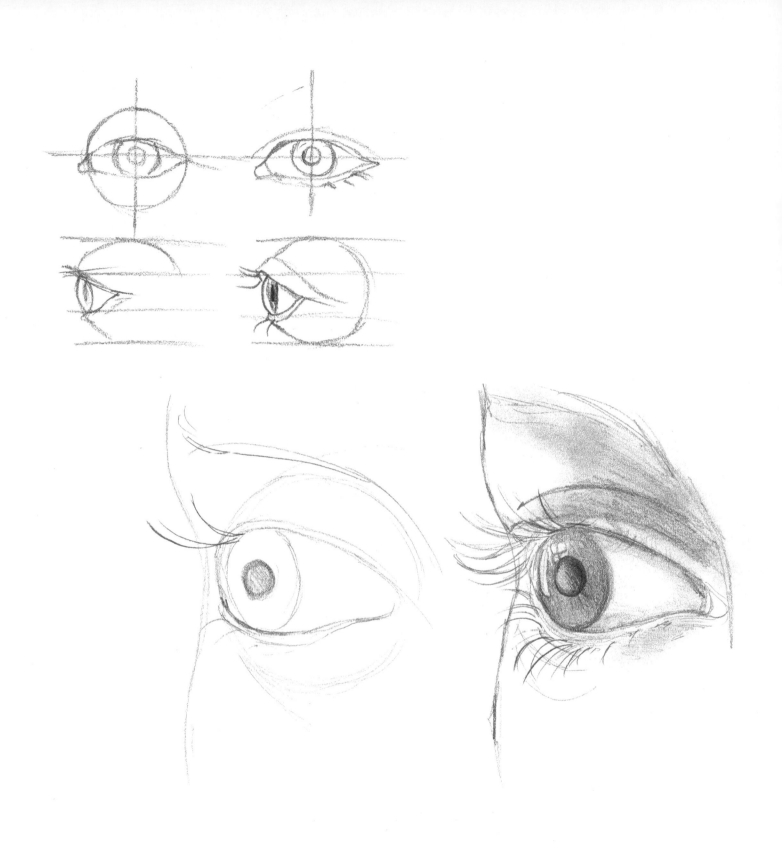

In these drawings you can see how the eye is drawn using circles representing the pupil, iris and eyeball. In the large image you can see this technique applied in more details. You can also see how highlights, reflections and shadows have been drawn onto the surface of the eyeball to make it more three-dimensional.

CONSTRUCTING THE NOSE

To draw the nose, use circles to represent the tip and the nostrils. Sketch the edges and bridge of the nose, shading triangular volumes and curved lines. This will correspond to the shapes of the nasal cartilage that forms the nose.

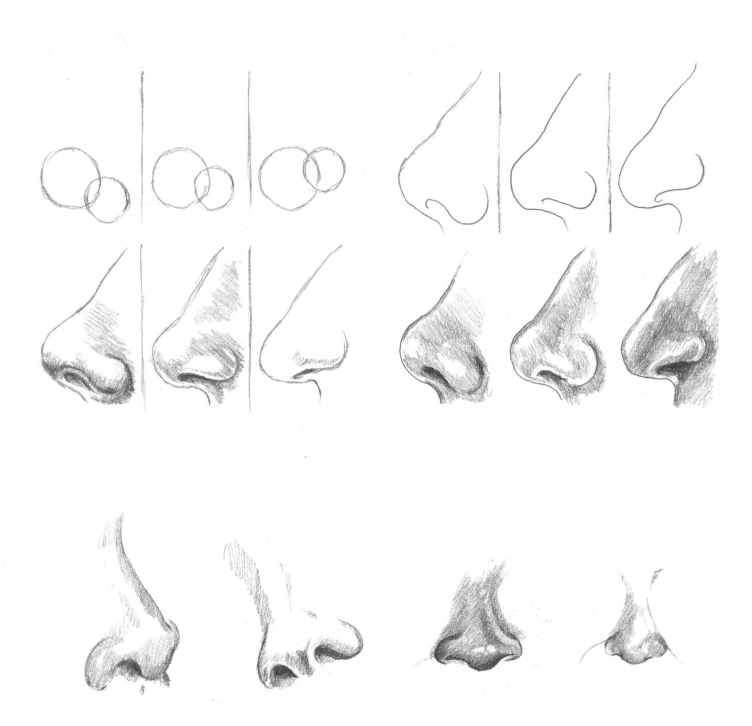

These images show how circles can be angled and arranged differently to construct different-shaped noses. Circles of varying size are used to estimate a corresponding structure in your model. Combining circles with curved lines to map out the edges of the nostrils and bridge can be used to show where to place shading and tone.

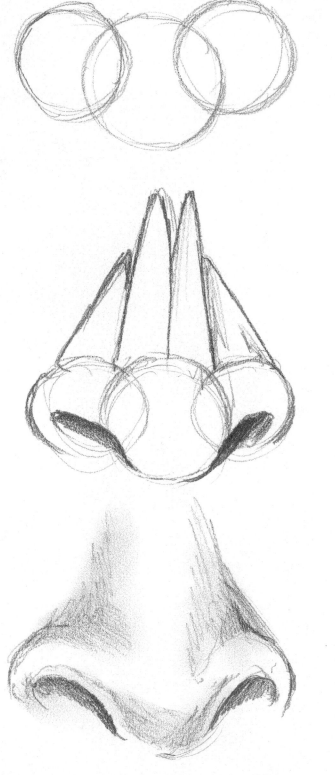

1 *Nasal bone*

2 *Triangular cartilage*

3 *Alar cartilage*

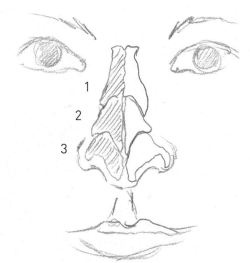

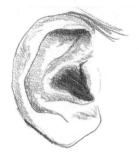
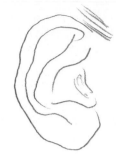

CONSTRUCTING THE EAR

Practising using curved lines and shading to draw features such as the ear can be done from different angles and will increase your familiarity with what kind of curves help to construct the ear as seen from different angles.

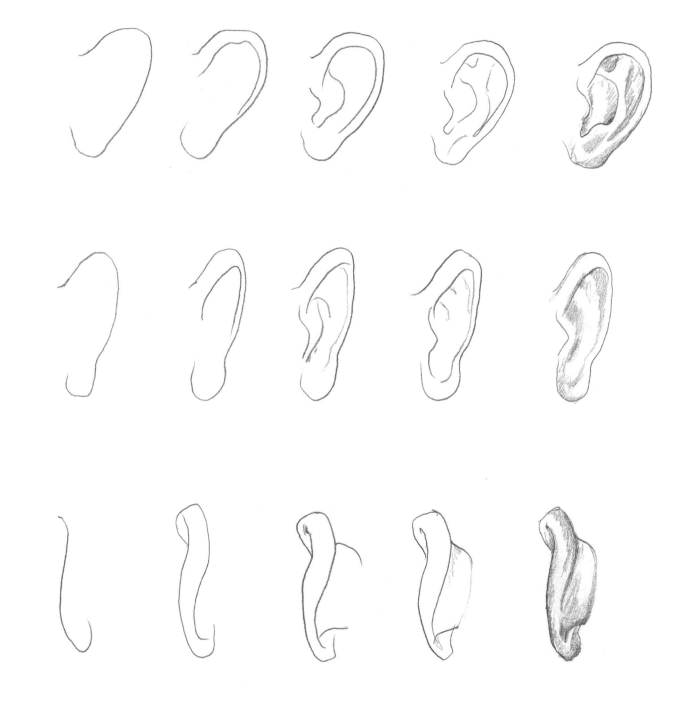

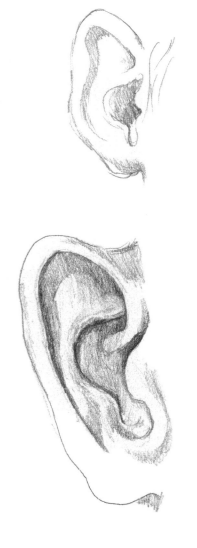

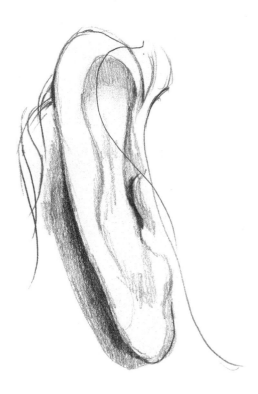

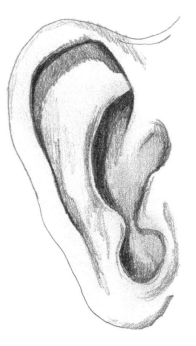

In these larger drawings you can see how the hatching is more intense in the more shadowy and deeper parts of the ear. Stray hairs have been added to show the texture of hair that falls around the ear.

CONSTRUCTING THE LIPS

The lips can be constructed in a very similar way to the other facial structures. Often, the mouth is symmetrical. Sometimes it is not. Whether it is symmetrical or not, divide what you observe into quarters.

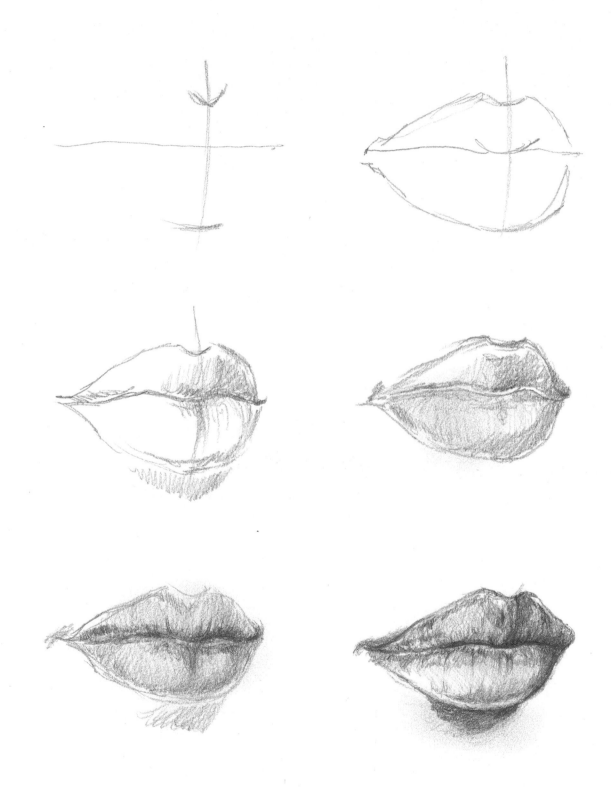

PLACING THE MOUTH ON THE HEAD

Using ellipses and lines can help you can place the mouth at the decided position on the head. Here, the head is tilted and the mouth is therefore also tilted.

You can see in the first image that the eye line is not halfway down the 'egg shape' used to sketch the face; this is because the head is tilted back slightly.

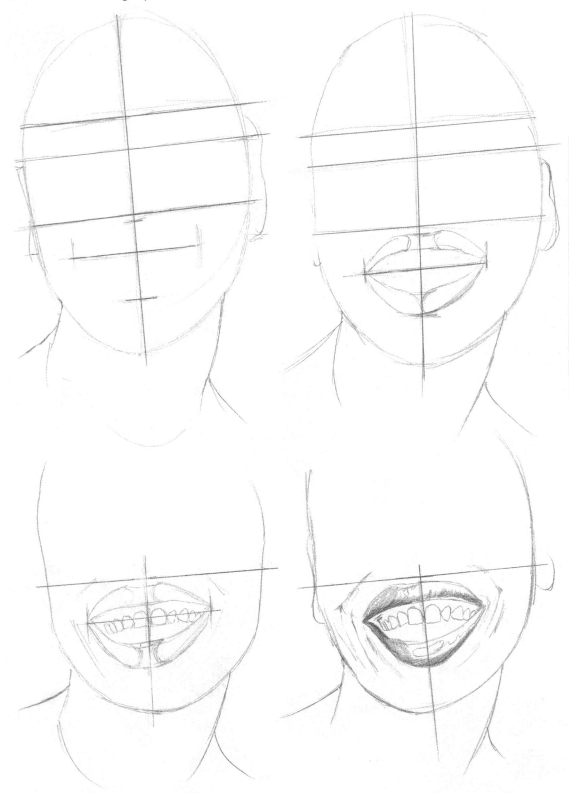

PLACING THE NOSE ON THE FACE

Placement of features such as the nose on the face must be done using the line of bilateral symmetry and ellipses you have sketched on your egg and ball shape.

In these examples hatching has been mainly used to estimate and mark out shadow. This makes for a quite stylized drawing that still shows shadow and depth.

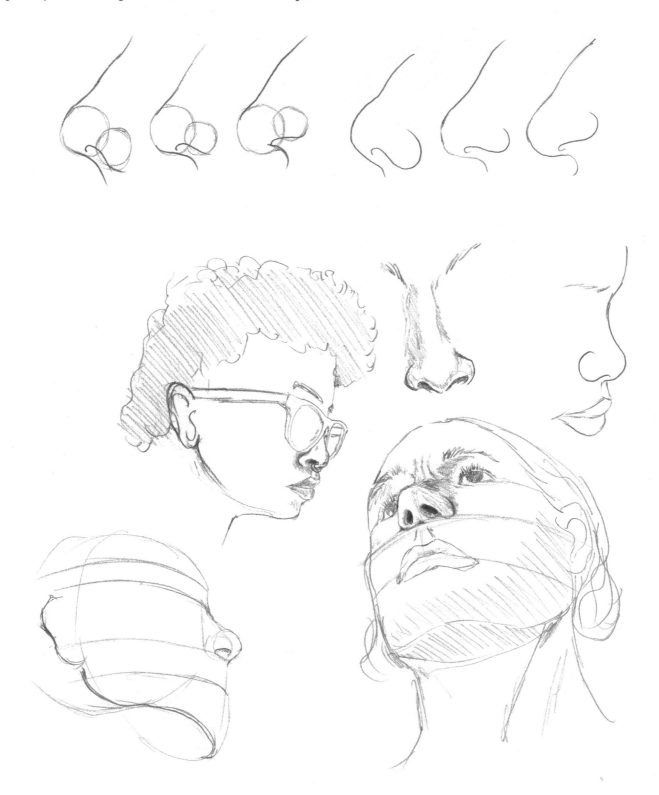

DRAWING THE FACE SIDE ON

In this example, the tilt of the model's head is seen from the side, facing to their right (our left). The whole of the body is facing the side, and their head and shoulder are leaning forward towards their right slightly. You can tell this from the shape of the neck: posture is an important detail in figurative drawings.

The posture or post of the figure is very important in figurative drawing and there are many ways of ensuring the posture of figures is captured effectively. Posture, pose, expression and detail are all interrelated. These different concepts (or principles) are discussed in their own chapters.

In these drawings focused on the face, the model sat in multiple sittings, and photographs were used to help guide drawing and help the model return to the pose.

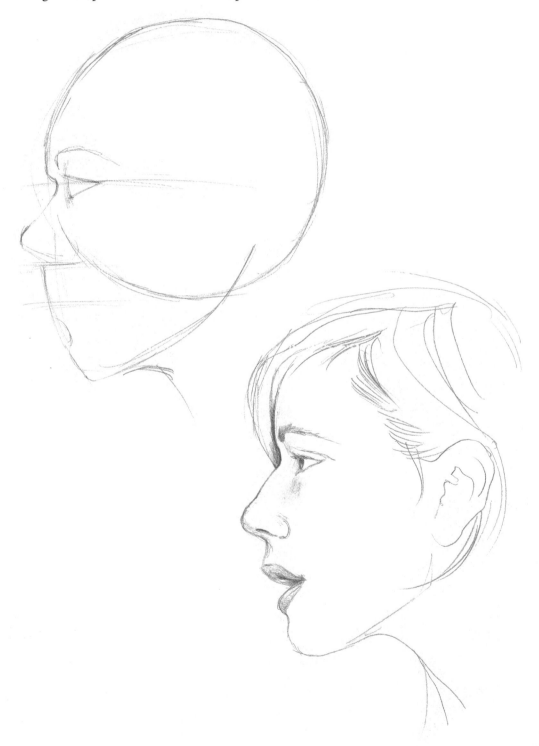

DRAWING THE FACE

In this example the model is looking straight on with a slight tilt towards their right shoulder.

First the egg and ball shapes are drawn. Next the 'eye line' has been roughly sketched in and a line down the centre of the face. The nose and mouth are marked in with lines showing the edges of individual structures: nostrils, edges of mouth, top, bottoms of lips etc.

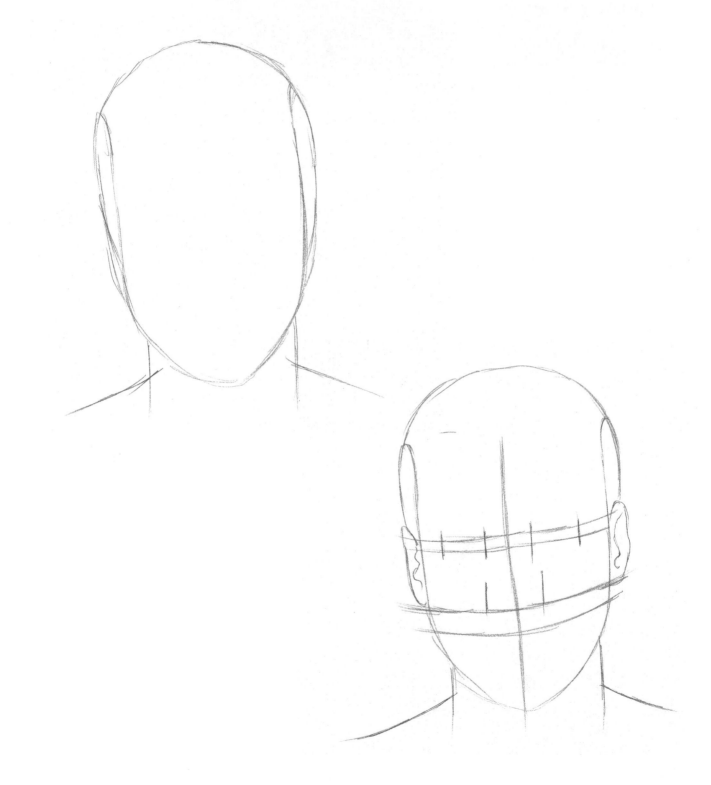

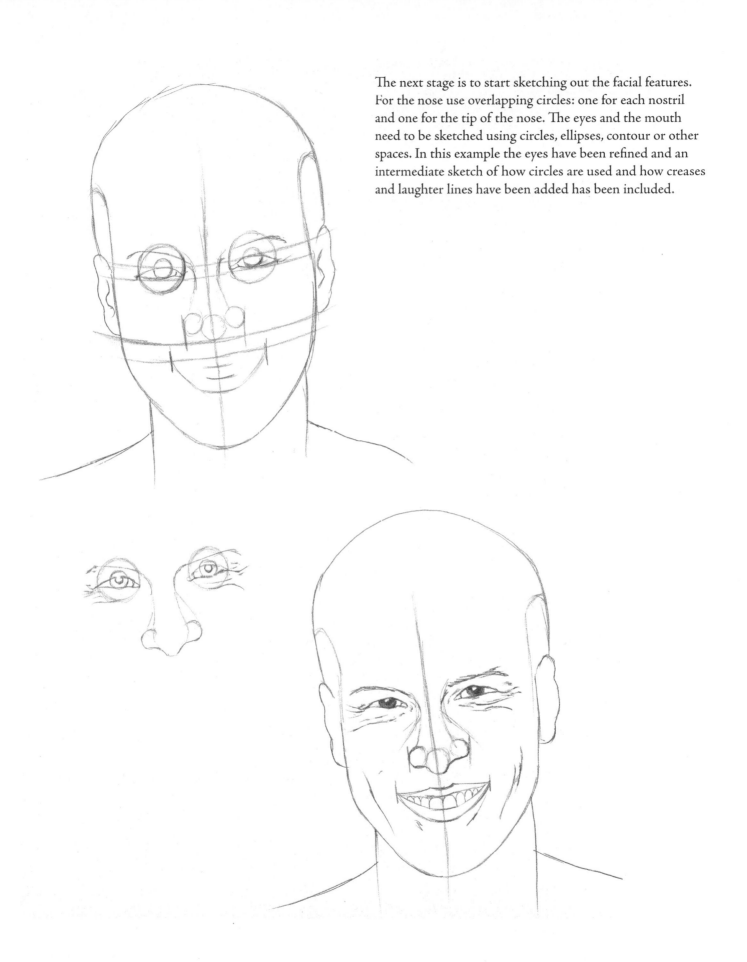

The next stage is to start sketching out the facial features. For the nose use overlapping circles: one for each nostril and one for the tip of the nose. The eyes and the mouth need to be sketched using circles, ellipses, contour or other spaces. In this example the eyes have been refined and an intermediate sketch of how circles are used and how creases and laughter lines have been added has been included.

DRAWING THE FACE TILTED AND FACING UP

This example was completely developed using a photograph. When posing the model, I gave them something to look at and guided them through the pose to help them feel comfortable. Here, the tilt of the model's head is looking up and slightly to their right (our left). First the 'eye line' has been sketched in as an ellipse. Then the nose and mouth, with lines showing the edges of individual structures: nostrils, edges of mouth, top, bottoms of lips and so on.

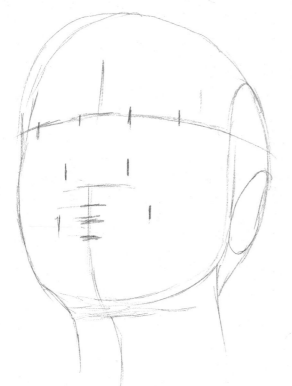

The next stage is to start sketching out the facial features. For the nose, use overlapping circles: one for each nostril and for the tip of the nose. The eyes and the mouth need to be sketched using circles, ellipses, contour or other spaces. For the mouth I have used contour, for the eyes, circles.

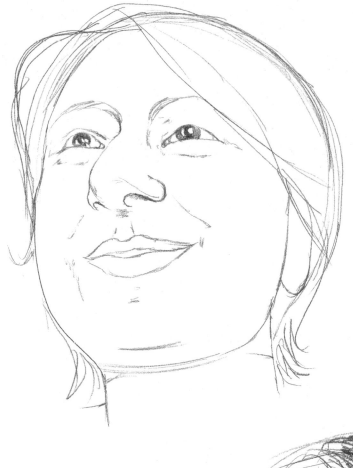

Once the shapes have been sketched in, use contour to refine the shape of the eyelid and outer and inner edges of the nostrils as well as laughter lines. Begin shading in the iris and pupil. When you are happy with the details and contours you have sketched in place, begin to add more tone and texture.

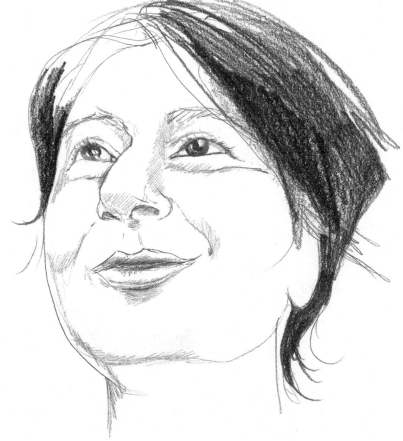

DRAWING THE FACE AT THREE-QUARTER VIEW

This drawing was also developed using a photograph of poses which I guided the model through. In this example, the tilt of the model's head is a three-quarter view to their left. Add the 'eye line' with a partial ellipse.

Begin sketching out the nose and mouth with circles, lines showing the edges of individual structures: nostrils, edges of mouth, top, bottoms of lips. For the nose, use overlapping circles.

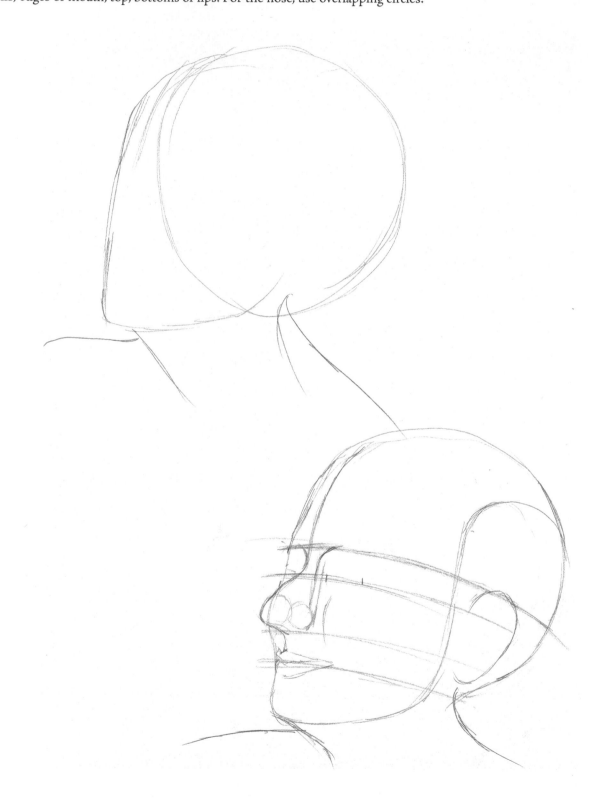

Drawing involves gradually adding and refining by removing marks, construction lines and ellipses with a putty rubber. Add the hair, eyes, eye details, mouth and shadows. Tone is a really interesting way to develop a drawing so the initial sketching and construction should not be your main focus. Practising the earlier stages of construction lines multiple times on paper is a good way to refine your skills in this type of drawing. As your confidence increases you will find it more exciting to start working with tone.

FORESHORTENING

Using perspective can help with an optical effect called foreshortening that can make a figure look out of proportion. Stylistically this can be a lot of fun to experiment with, but it can be frustrating for students to draw a foreshortened figure without understanding how to make use of perspective to help make it make sense as a drawing.

In this image I have sketched the whole figure in simple shapes and then placed the contour of the figure within a long rectangle in perspective which I used to guide the drawing. Creating drawings like this is another way to practise accuracy, and one could dedicate an entire sketchbook to images of foreshortened figures drawn up to this stage.

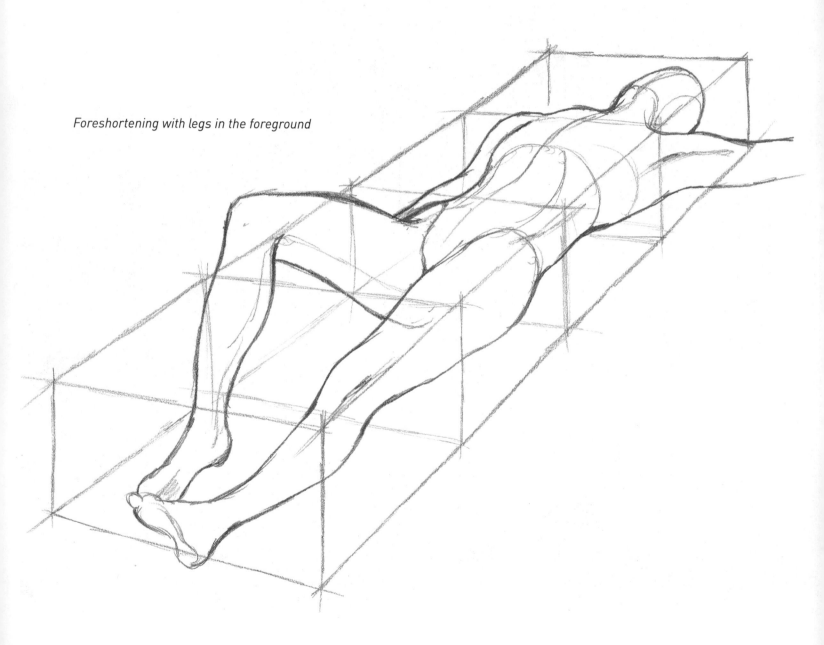

Foreshortening with legs in the foreground

As well as drawing a whole cuboid in perspective for the figure to be sketched into, you can also simply draw converging lines to help guide the shapes that you use to construct the image.

This example was developed from a photo where I stood on a chair. In the first drawing you can see roughly drawn construction shapes with two lines either side of the model's torso, converging towards, but not at, the feet.

In the second stage, hatching has been used for shadow, and contour lines of varying weight to emphasize shadow, which also help to make the image make sense.

SKETCHING PRACTICE

Quick contour sketches are helpful to develop your drawing skills.

Remember that there is no way or method or style of drawing that is superior to any other. Do not be put off by the drawing not being exactly what you want it to be. All drawings are part of an ever-evolving practice and the key is to do it little and often, and to have short-term goals (such as refining figure drawing).

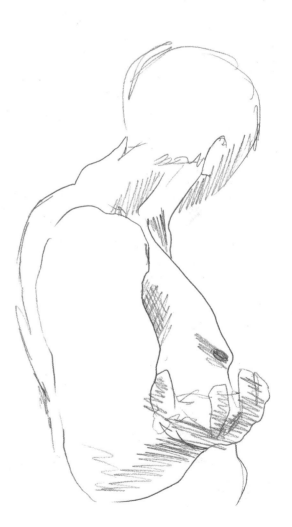

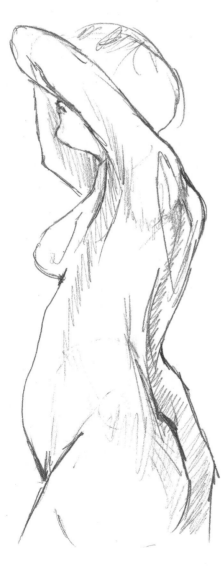

TILT AND ATTITUDE

The use of variable lightweight line was particularly useful in this drawing. Mainly because the model's pose had a lot of personality and attitude that could be captured by emphasizing the weight distribution of the model themself.

Chapter 5 is dedicated to pose and posture which you can refer to for more detail. But the pose is all about the mood or ambiance of a pose. In this pose, the personality and mood come down to the tilt in the head, which is totally horizontal, straight and ever so slightly tilted back. The shoulders are also horizontal. The hips, however, are not: the left hip of the figure is tilted down, with the left hand on the hip and right hand held up as if they have just clicked their fingers.

If you try and put yourself in the same pose as your model you may understand weight distribution a little more intuitively. I have used a heavier line for the leg that is in front of the other, simply to emphasize that it is in front. The armpit and hip have been emphasized with a heavier line and where the hand is placed on the hip, a heavier line is used to emphasize the shadow that was formed in this pose.

EXPRESSION IN THE ARMS

In these drawings I have focused on contour; however, for the hands I needed to construct them using simple shapes. I found it difficult to create the pose with the arms crossed over the body, particularly the hands clutched around the arms. I resolved this by combining both contour and the use of shapes, and began to sketch the hands in a way that showed the depth I wanted to recreate.

You don't have to use just one method for the whole body, you can use partial methods and combine them in any way you please.

PRESSURE IN THE HANDS

In this example you can see how tone is being gradually added to a drawing. I tend to switch between putty rubber and pencil, almost like a conversation between the two when I remove construction lines. I never remove them all at once, always gradually and never spending too much time in the same area of a drawing.

In the tone you can see the texture of the hatching used as well as the range of tone from darkest and most intense to lightest.

EXPRESSION AND ATTITUDE IN THE HANDS AND ARMS

This pose evokes quite an emotional response. The model's hands are clutched around the back of the head and neck with the head cradled into the arm. It feels quite protective and enclosed. I have treated the hands quite differently: the forward hand emphasizes the knuckles, while the hand above is lightly shaded to create shape, form and tone.

LEGS: STATIONARY AND IN MOTION

These are quick three-minute studies of the model's legs created using long curved lines, circles, ovals and simple oval-like shapes.

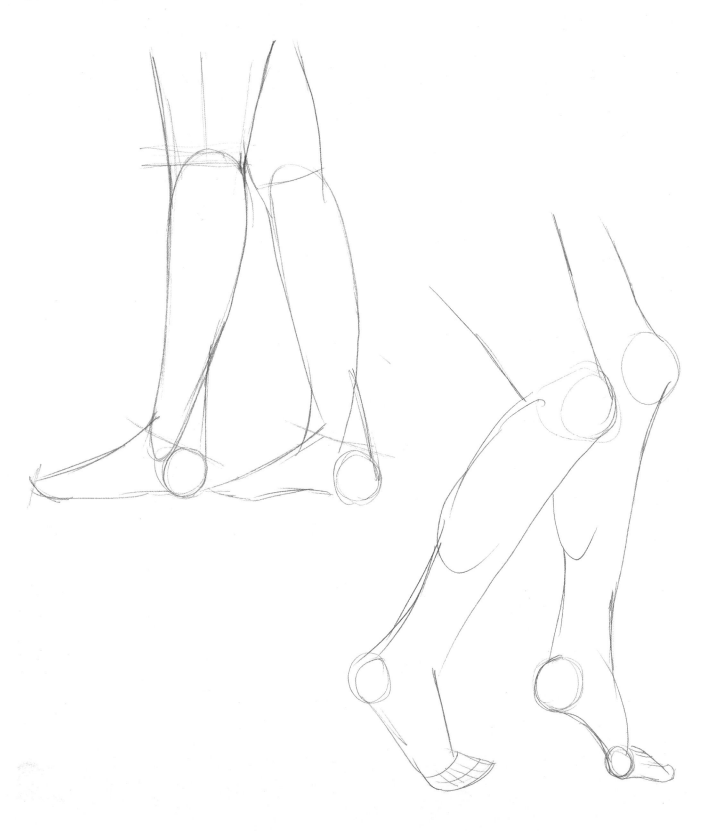

VARYING WEIGHT DISTRIBUTION

This ten-minute study was developed from the previous three-minute study. As this is a pose that is very hard to hold for a long time, it is important to be considerate of a model's needs and to work quickly so they can rest and replenish.

Contour has been used to sculpt the anatomical forms visible on the model. For longer studies it can help to take a photograph, with the model's consent.

In a pose like this, a quick three-minute study was carried out with the life model, and a picture was taken, and then the drawing was then developed over the next ten minutes. Taking pictures can be helpful for both artist and model to recall the details of poses, particularly if it is necessary for the model to return to the pose.

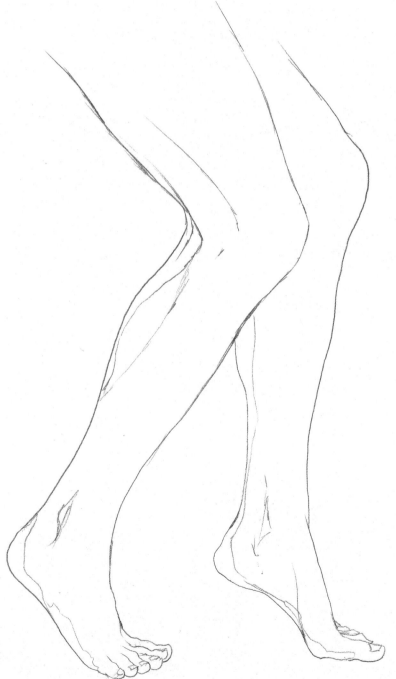

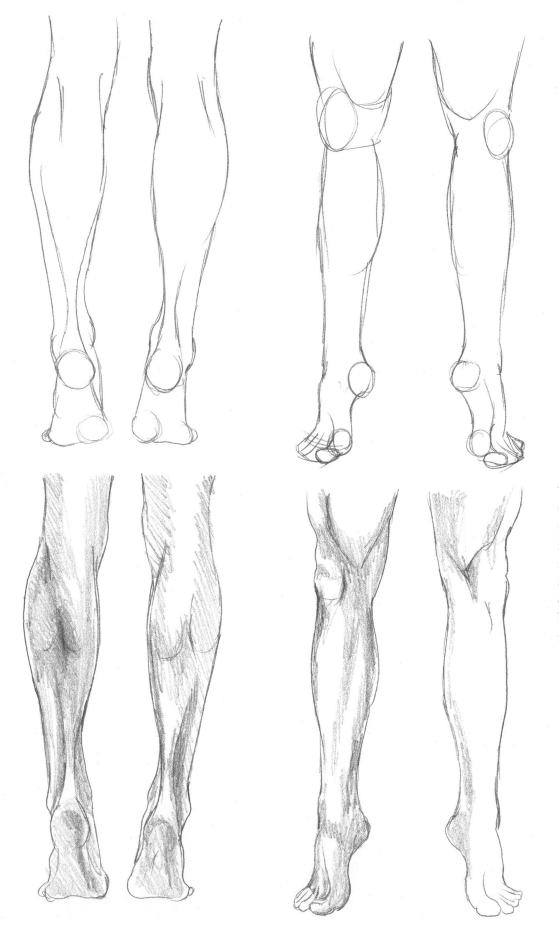

The two upper images were quick studies, where the model held the pose for no more than two minutes. The second studies were developed over additional short bursts between two-minute breaks.

In this image the model was seated and, as the legs were crossed, the big toes are drawn on the outer side of the feet. This pose was a little bit easier for the model to hold for a longer time. The model held this pose for 15 minutes; the pillows they were sitting on on the floor were omitted and I was positioned standing above them. I chose to stand because I wanted to capture a view directly down and minimize foreshortening.

The block drawing without the length of the legs to add context to what we see makes the image seem very unnatural. In the tonal drawing, the shading has been done gradually and line weight helps to add to the shadows formed between the two.

FEET

Drawing feet can be very challenging. Feet, much like hands and faces, are often unique to the person. Capturing the uniqueness of someone's hands or feet can help create a very special drawing. Applying the principle of capturing the whole figure using blocks or geometric shapes and then introducing contour to 'carve into' the blocks using pencil is one way to develop your skills.

In these examples you can see the kinds of blocks used and the details added using contour that carry the line weight. An arch, for example, is a useful scaffold for placing toes and toe joints. Sometimes toe (and finger) joints don't always line up: toes might be a little bit longer or shorter – this is what makes them unique. Sketching in the arc anyway is helpful for figuring out the unique proportions you see in the foot and toes. In the drawings of the sole of the foot you will notice how an arc has been used to help align the tips of the toes.

DRAWING THE FACE FACING UP AND TILTED BACK

In this example the model's head is looking up and tilted back with their eyes closed. The 'eye line' has been sketched in as a partial ellipse. The eyes have been sketched as circles and the brows arch above the eyeballs. This was chosen because the brows and closed eye were prominent and expressive in the model's pose.

The next stage is to refine the shapes of the facial features. Keep practising the earlier stages of a drawing; it can be very helpful to repeatedly create or practise creating the same image. Dedicating a whole sketchbook to these initial stages of a portrait or figure drawing is an excellent way to develop your drawing.

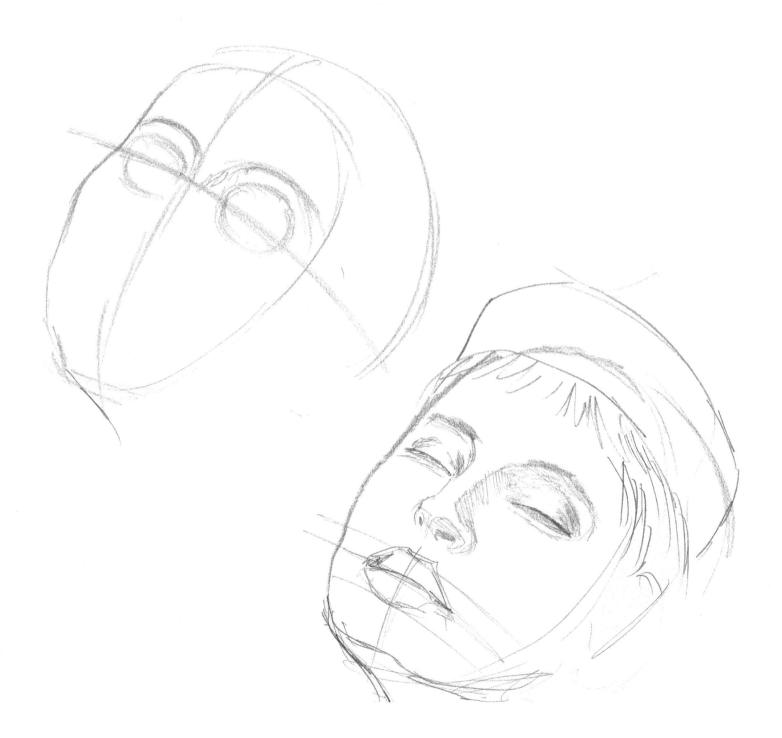

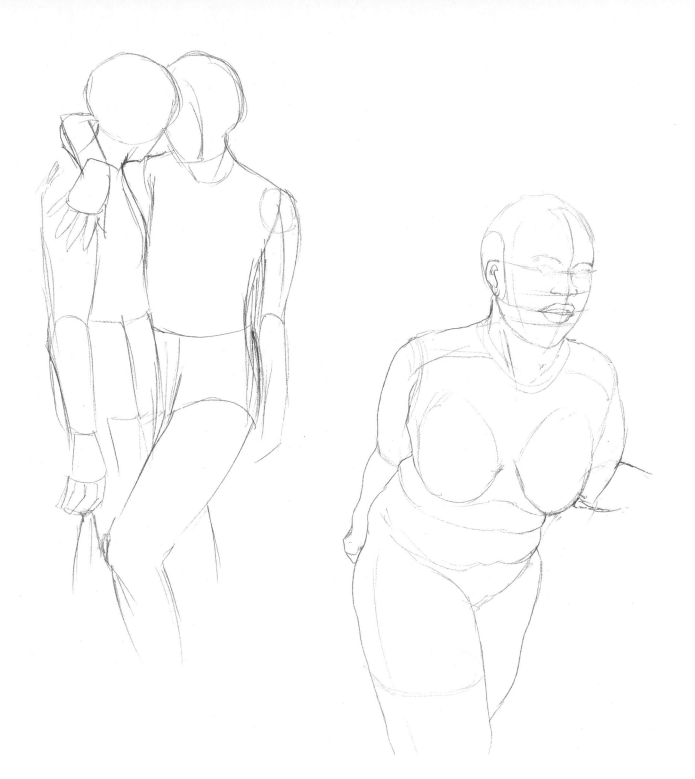

These quick sketches show models leaning. The top one shows two models who are standing close to each other, leaning in in an embrace. Fewer details have been included in this image and the sketch was produced in just seven minutes. The leaning in, arm over shoulder, and bent leg of one of the models required more time to capture.

The other sketch shows the model leaning forward, one leg in front of the other, with the torso tilted slightly over the hips with one arm behind their back and one arm leaning on a surface. This image was a more straightforward drawing as it includes only one model; however, as more contour and detail was added, it took about 15 minutes to carry out. The model held the pose for ten minutes.

RETURNING TO THE SAME POSE AND USING PREVIOUS DRAWINGS

These poses were held for five- and 15-minute intervals. A mirror and photographs were used to help the model return to the pose after breaks.

The first sketch was a three-minute sketch. The second sketch took four minutes, and I was able to lead some of the construction of the drawing with contour as I had already familiarized myself with the pose in the first sketch and could refer back to it (although I forgot to include the folded leg).

Returning to the same pose and redrawing it is a good way to practise and an effective way to create a more detailed study if you wish to develop a more 'resolved' study or portrait. Refining the contour in the third image took about 15 minutes, which was the maximum time the model wanted to hold the pose. The fourth drawing was developed from a photograph and took just under 20 minutes, using the previous images to help me construct the figure.

In the remaining two drawings I worked mainly from the previous sketches and the photograph; they took about 25 minutes each. I asked the model to sit in the pose for a final five minutes to help me capture some of the shadows and reflections for the final and sixth image.

These poses were also held for three-to-ten-minute intervals. A mirror and photographs were used to help the model return to the pose after breaks.

The first sketch was a three-minute sketch. The second sketch took ten minutes using construction lines; this was a longer drawing because I was sitting close to the model and could see more detail.

The next two drawings were built using the previous two and a photograph. To develop this drawing further and make the final drawing less flat, with more tone and expression, I would need the model to sit for a further ten to 15 minutes so I could more carefully observe how light and shadow affected the texture of their skin and hair. Using simple lines for the pattern on the bra creates a graphic stylized effect and contrasts with the volume of the body.

DRAWING A SEATED FIGURE

This drawing incorporates a somewhat complex foreshortened pose as well as many of the aspects of the body explored earlier, including head tilt and gaining expression through the arms.

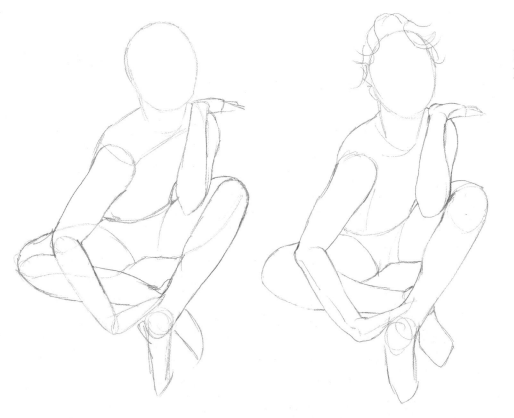

Create the main parts of the body using boxes and lines. Mark the kneecaps and the position of the hand and feet.

Add in the outlines of the arms and legs and draw a more natural line for the shoulders.

Refine the contours and erase overlapping lines and structural lines.

Start to add detail:

+ Add curves and structure to the hand;
+ Add detail to the arms including the shape of the elbow;
+ Add the structure of the hair.

Add symmetry lines to the head. As the head is tilted back, the line for the eye is higher.

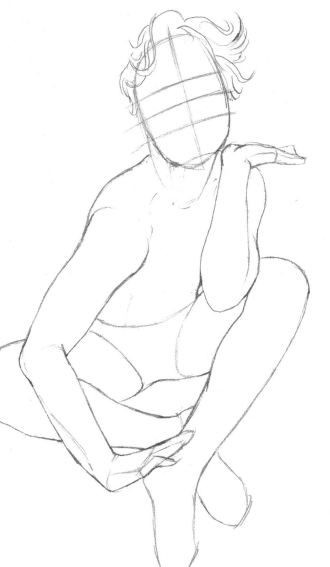

Refine the curves around the back and the arms and legs. Erase the ball shapes in the feet. The next stage will be to map the face and details of the clothing.

Add dividing marks or lines on the lines that divide the head shape. This is to map out the eyes, nose and mouth.

Remove more structure lines and shapes and start to add shading around the arms and legs. Emphasize shading to create shadow where the arms and legs meet or touch.

SHADOWS, TEXTURE AND TONE

In this chapter we go into more detail about how to create variation in tone and texture on the figure. This involves hatching, close hatching, line weight and varying the intensity of the tone you create. The technique I use to create tone is to lightly outline areas of light and dark, creating a 'paint by numbers' drawing that you can level out with close hatching. You can then blend with your fingers or a special blending tool and smudge with a putty rubber.

If you look very closely at these drawings of a sphere you can see how I have sketched out the lightest and darkest part of the sphere. In the tonal drawing you can see the range of intensity and that each tonal shade is blended into the next. The tonal sphere also shows a light reflection in the shadowy part which was observed in the drawing. Reflections under the chin or within the eye deserve your attention and to be captured, as the light and shadow can really work together to create depth and detail in a drawing.

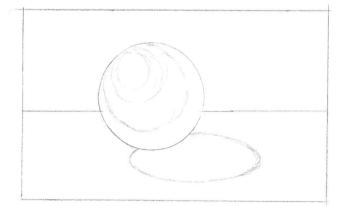

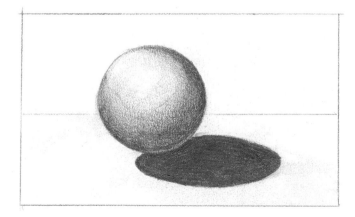

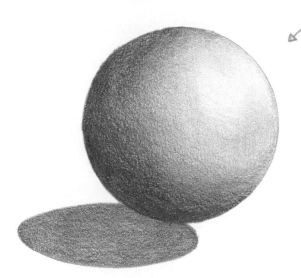

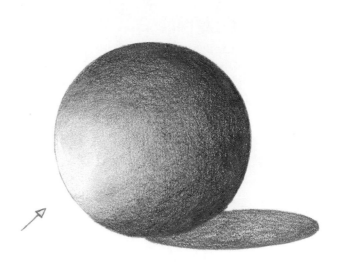

TONE AND SHADING

You can experiment by drawing an egg or a ball with light shining on it from different angles. Take your time with studies like this and really try to practise creating a smooth gradient. The gradient itself will vary depending on the nature of the light source. A diffuse light or overcast day will cause less extremes in tone; a bright, sunny, intense light will create a more dramatic difference.

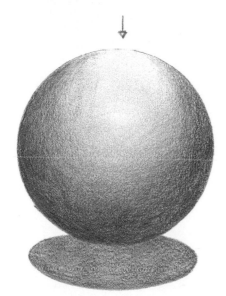

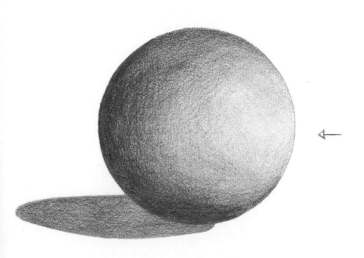

It is more effective to vary the softness of your pencil and apply layer upon layer of a softer graphite from HB to 9B to create more intense tones. Never press hard, unless you are creating a specific feature.

TONE AND SHADING ON THE FACE

In this image you can see the light reflecting under the jawbone and on the chin under the lower lip. These were actually created by using a putty rubber formed into a long shape and pressed on to the drawing to repeatedly lift off layers of graphite until the appropriate amount of illumination was achieved. In this image a slither across the jaw was enough to create the impression of illuminated skin.

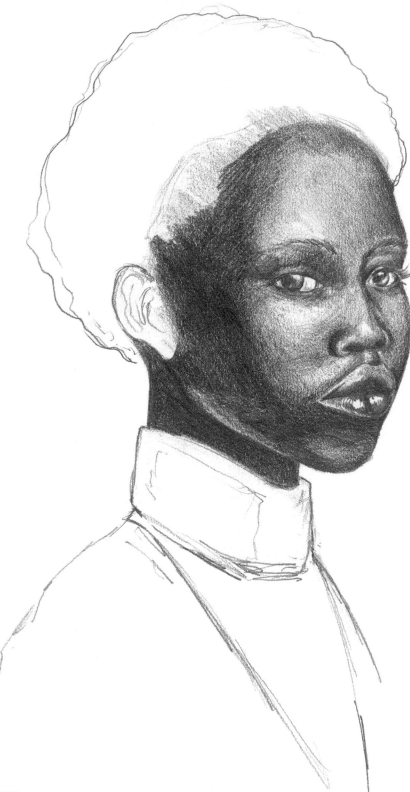

Here you can see the outline of the different shaded edges and how this translated into a tonal drawing. This drawing was carried out in five-minute sittings and working from a photograph.

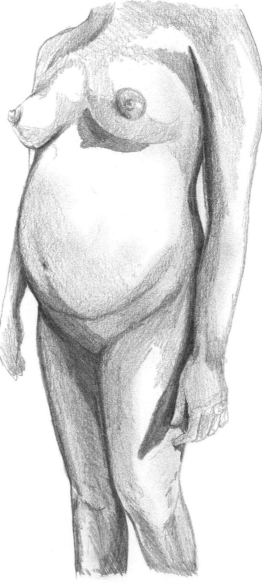

SHADOWS, TEXTURE AND TONE

Outlining variations in tone can be helpful in practising observational skills as it encourages you to think about the face or body in a topographical sense, helping you to understand the figure as a landscape. The technique of sketching tonal edges takes in depth and surface, creases, and light reflecting off and being scattered across the skin. The features of the face closest to the light source will be the most illuminated. Thinking of the face and figure topographically can make sense, instead of elevation. However, it is also about their contact with light and shadow. These staged step-by-step drawings are examples of how you would apply this technique.

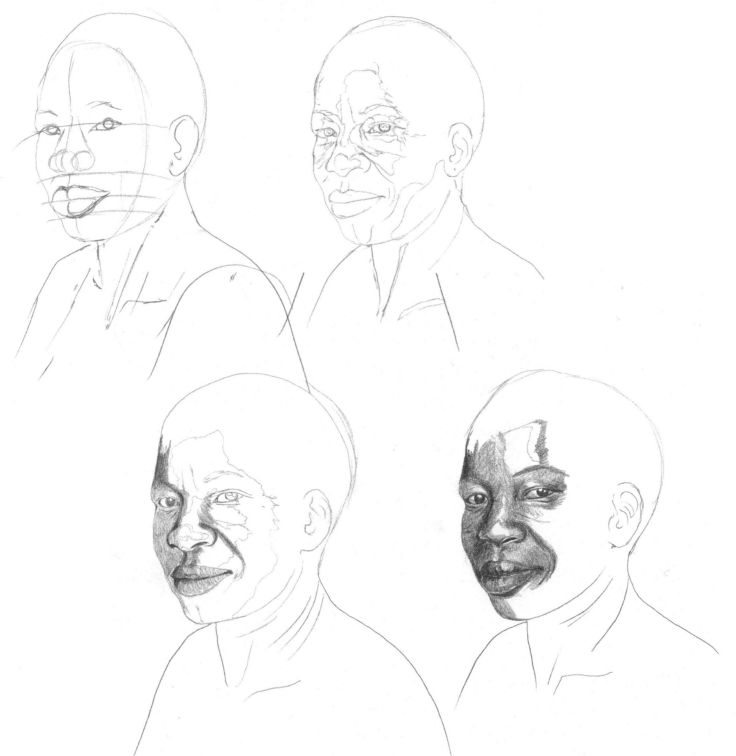

In this example you can see incrementally how tone has been added and blended on the face and neck. The hair in the fourth drawing could benefit from some more stray hairs to make it look more fluid.

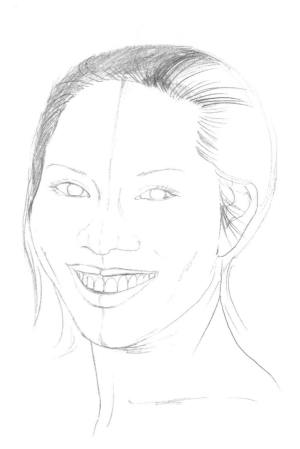

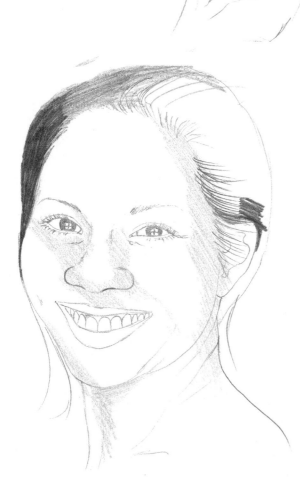

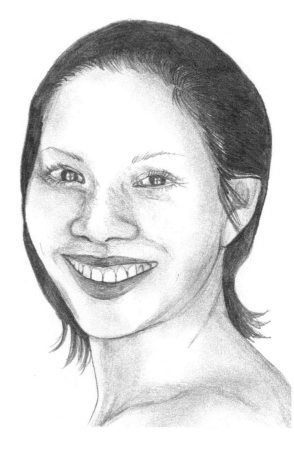

DRAWING AND SCALE: STEP BY STEP

Making a larger-scale drawing can enable you to capture more details. In this example we begin with the ball and egg, drawn from the side.

Next the eye line, and position of the nose and lips are marked in with a curved line. The eyes, nose and mouth are lightly marked using circles.

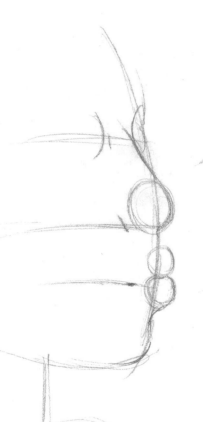

Add the eye socket, and mark where the nose and mouth end.

Contour is then used to create the form of the eyes, nose, nostrils, lips, forehead, chin and jaw.

Refine the shape of the nose and mouth.

Add in the eyes. Erase the horizontal lines.

More detail is added to refine the drawing to match the image of the model. Lightly mark where shadow falls on the face.

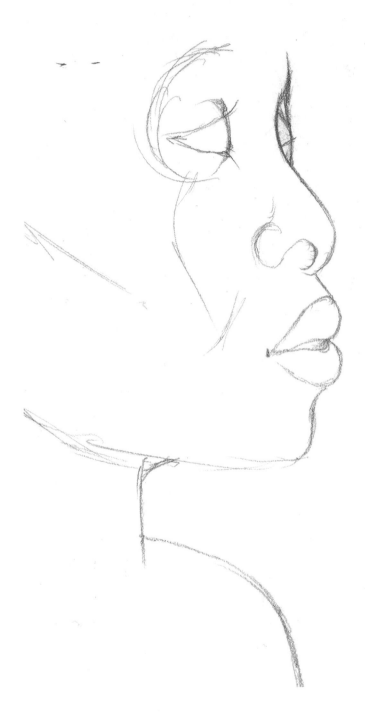

Find the line of the cheekbone and mark in the chin.

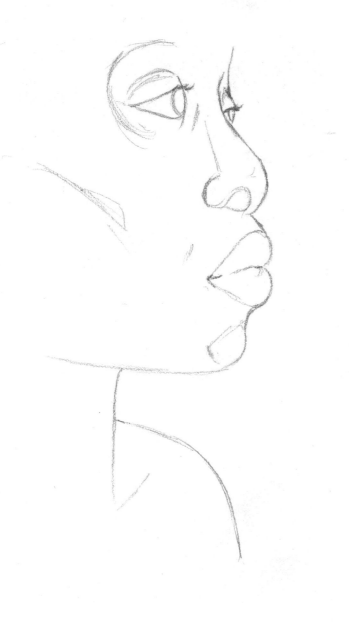

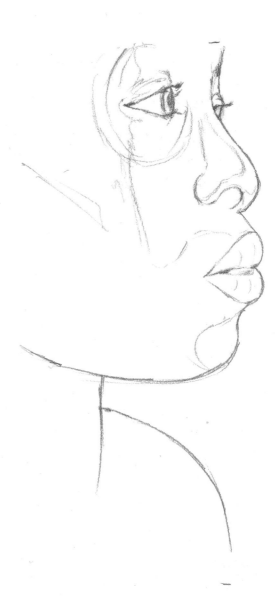

Add the iris of the eye and add detail elsewhere.

Shade the eyelid and the right side of the nose.

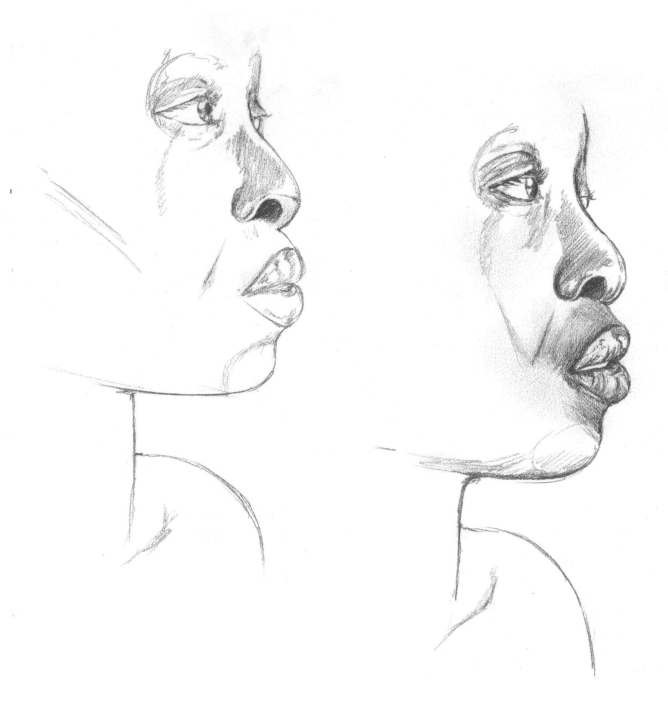

Add more shadow around the eyes and mouth and under the chin.
As detail begins to be added to the eye, you can see the benefits of creating a larger-scale image, as details within the eye and in the lashes begin to add personality and narrative.

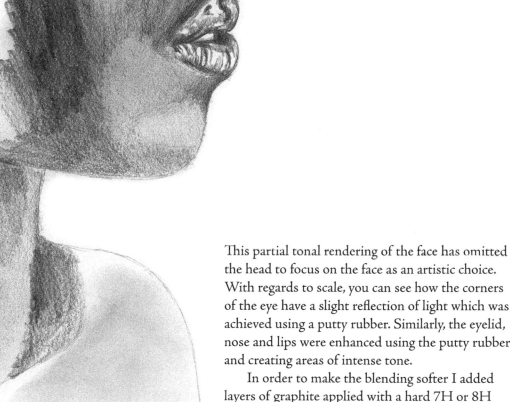

This partial tonal rendering of the face has omitted the head to focus on the face as an artistic choice. With regards to scale, you can see how the corners of the eye have a slight reflection of light which was achieved using a putty rubber. Similarly, the eyelid, nose and lips were enhanced using the putty rubber and creating areas of intense tone.

In order to make the blending softer I added layers of graphite applied with a hard 7H or 8H pencil, making it possible to gently and cumulatively fill in space in small circular marks. Blend with a blending tool and increase the density of the more shadowy areas. I like to use a mechanical pencil for this and work using HB or 3B pencil leads.

DRAWING THE TOP HALF OF THE BODY

I began with a quick sketch of the torso, arms and head.

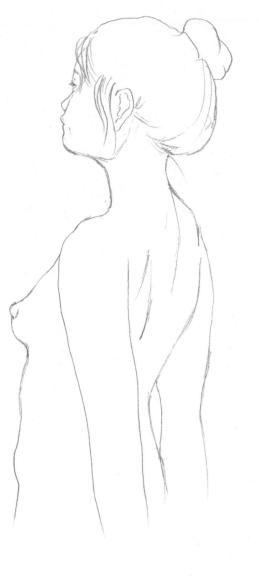

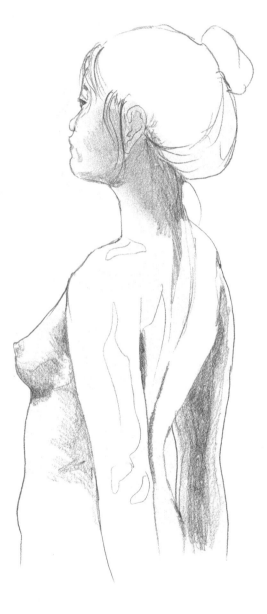

Where you have more time to attend to details of tone through repeated sittings combined with working from photos, you can experiment with blending gentle hatching to make the tonal differences across the figure more even. This does depend on the light source. If it is a strong focused light, tonal variation will appear sharp. In bright sunshine or under a focused lamp, you can see quite dramatic change while light on an overcast or patchy day will diffuse the shadows, making the figure more flat. You always have the option to exaggerate or diffuse shadows to expose or emphasize certain parts of the body, you just need to be careful and consistent with the direction of light and shadow.

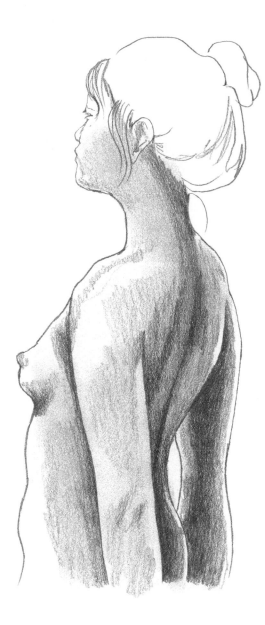

Here you can see the hatching lines and the beginnings of reflections on some of the bony structure of the back. If you want to blend your tone, you can do so by gently adding more with a lightweight or dense pencil harder than 7H or 8H. This makes it possible to fill in the gaps between the hatching. Gently and cumulatively fill in space in small circular movements. Blend with a blending tool and increase the density of the more shadowy areas. I like to use a mechanical pencil for this and work using HB or 3B pencil leads.

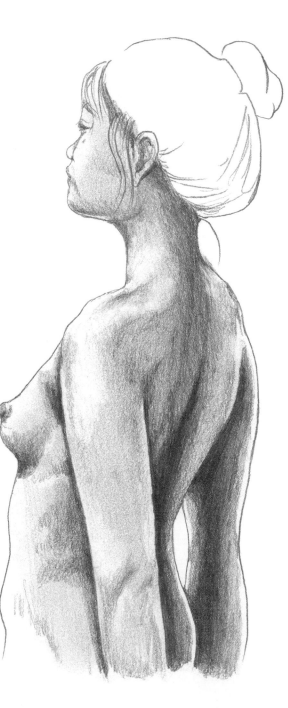

At this stage of the drawing, details of light reflected on the shoulder blade and back of arms and upper buttocks can be including using a putty rubber.

SUBTLE SHADOW AND LIGHT

Building up tone is also about removing layers of graphite to create highlights or reflections. Here you can see the model facing side on with their arms crossed across the front of their body and their head turned away from us with their left hand on the back of their head and jaw. You can see the back slightly and observe light reflecting off the bony structure of the back.

The highlights of light reflecting off the bony structure of the back are seen as slithers of white and we can create this in a drawing by using contrasting strips of shading and highlights. By using a putty rubber pinched into a smooth point and wiped along the outer edge of where the scapula (shoulder blade) is, you can remove thin layers of graphite in narrow strips. Aim to leave a thin, intense gradient representing a shadow where the spinal column is between highlights on the scapula.

By experimenting with the contrasts between tone, shadow and light you can create a sense of depth in a very small section of a drawing.

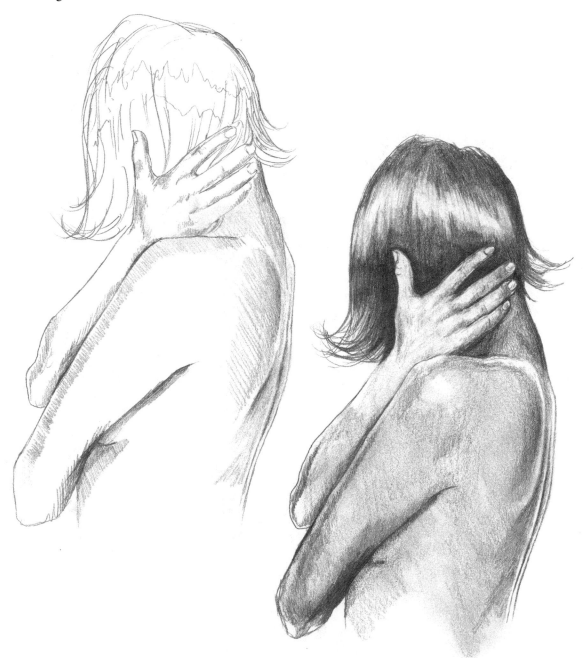

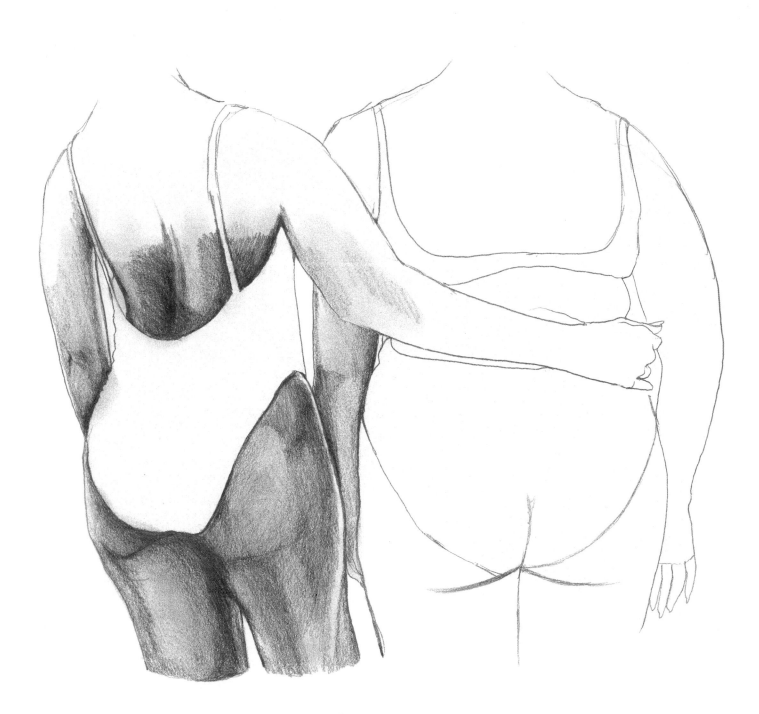

Here a larger range of tone could be added to create greater depth in the image.

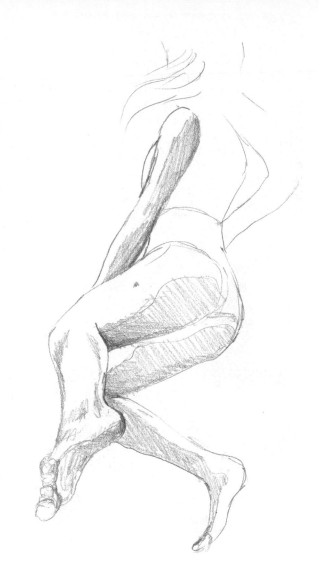

UNDERWATER: LIGHT EFFECTS

As with much of drawing, practice is key. Try working from photographs and the model. These images were taken with an underwater camera. Underwater hair appears very different and does not reflect light as brilliantly as it does in the air.

HANDS: SHADING AND TONE

Hands can be seen as almost a whole body unto themselves; they are very personal and unique to the person. Shading should be treated in the same way as it is when capturing other details of the body. Use varying line weight, putty rubber and mechanical pencil and, if possible, hard pencil and graphite.

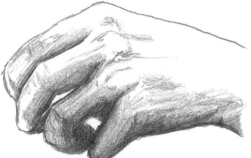

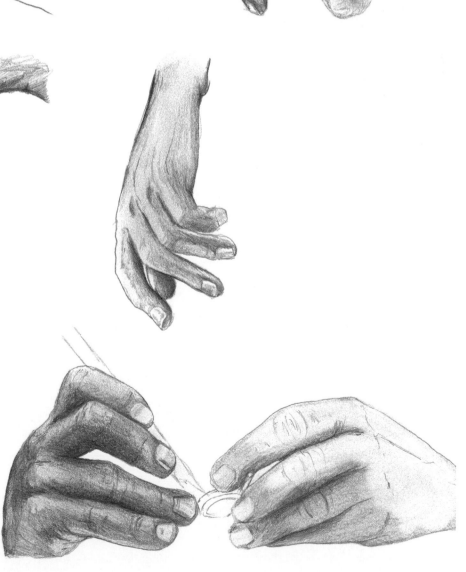

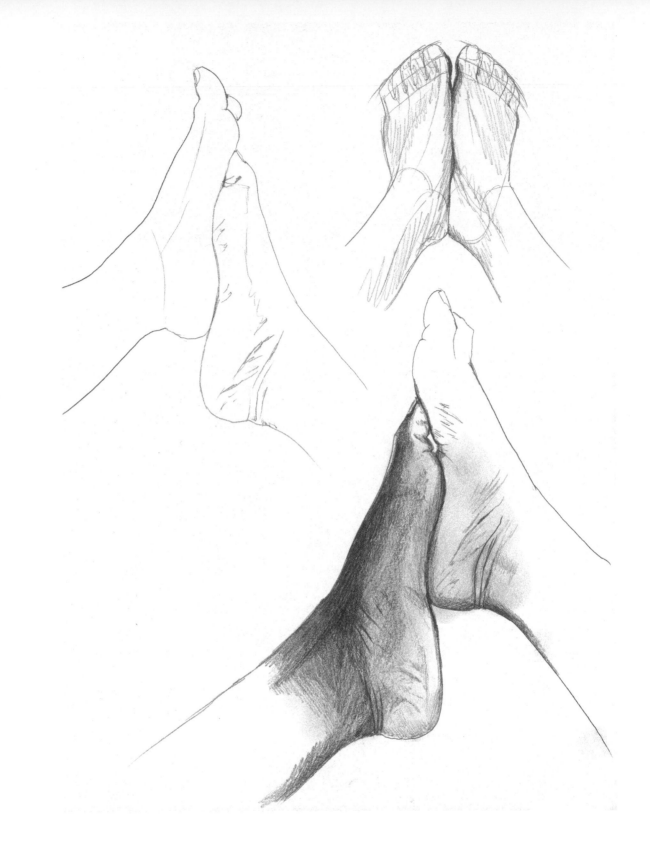

FEET: SHADING AND TONE

Both hands and feet are easier to shade in once you get their complex structures right. You can begin tonal studies with line, outlining shadows, then try with hatching and then add more layers of tone to experiment with techniques and outcomes.

HAND GRIPPING ANKLE: SHADING AND TONE

In this example you can see how outlining shadow and highlight, hatching, and more detailed application of tone have been applied. The foot has the most tone applied to it; the hand holding the ankle is also well rendered. The shin and buttocks have been developed with just a little hatching.

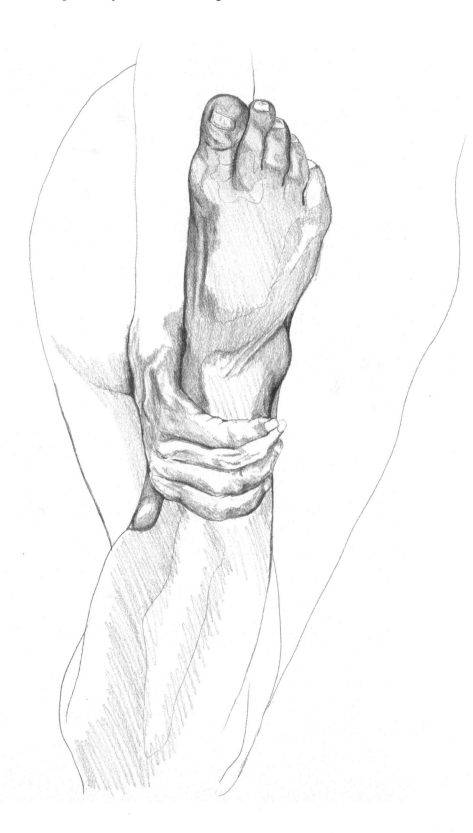

HANDS ON HEAD

Developing tonal range and shadow can suddenly make a drawing come to life. Try adding darkness to shadow, increasing tone to hair or face, and varying line weight.

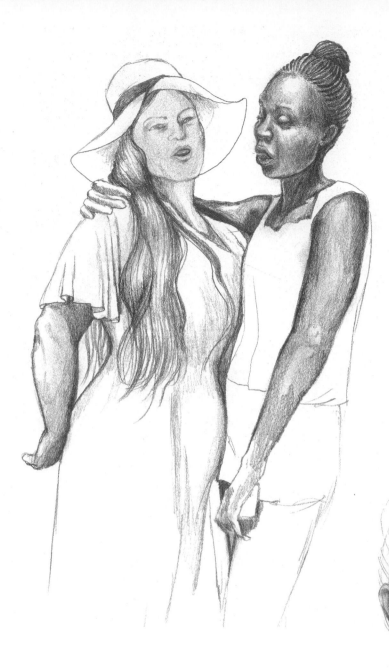

FRIENDS STANDING

When the facial expression is not perfectly clear you can use shadow to estimate this. It is possible to still create an expressive image using details on other parts of the body other than the face.

FRIENDS CLOSE-UP

When the facial features are clearer, create a larger-scale drawing so there is room on the page to capture and develop detail. In this example, tonal range, blending and highlights have been created using the putty rubber, varying line weight, hatching and cross hatching.

POSE AND POSTURE

This chapter builds from the previous chapter introducing/developing tone but focuses on pose and posture and what these are. Pose and posture include the curvature of the spine, weight distribution, tilts, narrative, mood and attitude.

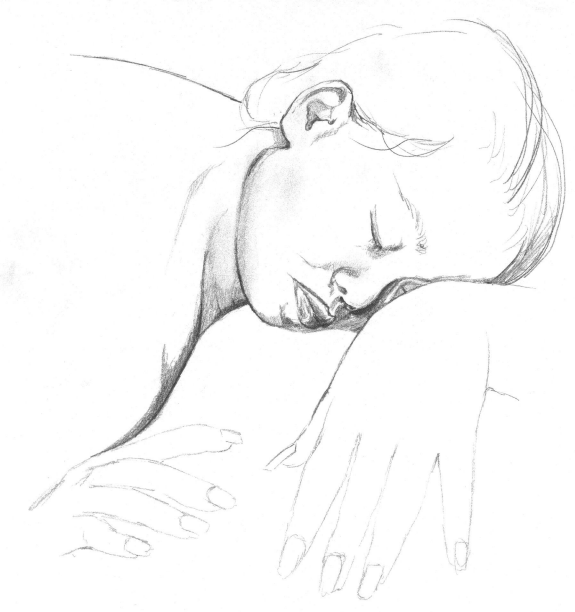

Tone, line weight and the interplay of shadow and light are discussed and demonstrated throughout. The technique of alternating between adding tone, using mark making to add texture, and the use of the putty rubber to lift layers of graphite will continue to be demonstrated; however, the emphasis will be on how the figure is enlivened through pose and posture.

POSTURE

Posture is an exciting component of a figure drawing. It simply refers to the position in which someone holds their body when standing or sitting. Posture is something that can be quite unassuming and we can be unconscious of it: whether we are slumped in a chair, leaning or pressing against something or seated upright with a straight back.

Pose is a more specific arrangement or stylization of posture, or a particular way of standing or sitting. Pose is more intentional and may be specifically adopted by a model to communicate a theme, attitude or mood.

This view is seen looking up at a standing figure, imagining the placement of the rib cage, shoulder blades (scapulae), pelvis and vertebral column.

TILT

Essential to the pose or posture of the figure is tilt of the head, shoulders and hips. Crucial to this is the back and spine and if there is a twist or curve in the spine. Identify tilts in the head, shoulders and hips using a straight line.

In this pose you can see that the shoulders are almost facing us, with the head turned to the model's left-hand side. Their left ear is tilted slightly towards their left shoulder so that we can see under the chin. The shoulder over their right arm is leaning on the chair. It is slightly lower than their left shoulder as their left arm is pressing up slightly on their left leg. Interpreting a pose like this, analysing it and trying to describe what the body is actually doing helps us to emphasize things such as the weight distribution in the model's pose and posture.

It is as if the whole pose is being propped up by the arm resting on the leg. When you observe the pose of your model, try to think about how tilt relates to weight distribution of the figure and think about how the figure is 'draped' in this way.

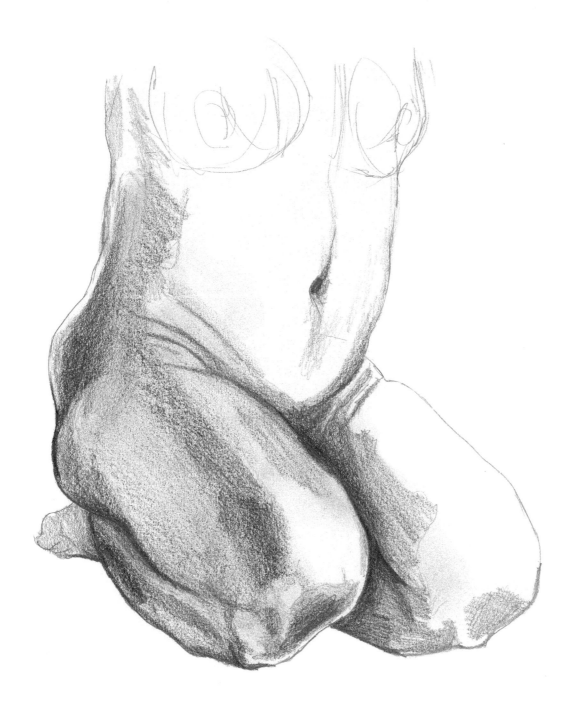

This drawing was completed using a 5mm HB mechanical pencil, a standard HB pencil that was sharpened, used on its side and allowed to go blunt. I also used a graphite stick for some of the shadowy bits as it created an interesting speckled texture. The different sizes of the leads and graphite stick means that the texture of the paper comes through differently. The finer the lead, the less visible the paper grain will be. Sometimes the paper grain results in really interesting and dynamic textures that are welcomed as part of the drawing. As you can see, the right thigh and torso of the model are incomplete, but in a way it doesn't really matter; the various techniques, processes and stages visible in a single drawing make it interesting.

BACK AND FORTH WITH TONE AND THE PUTTY RUBBER

It is hard to say when a drawing is 'finished'. There is no reason why a drawing that is 'in process' cannot be 'complete' or 'resolved'. Each stage of a drawing can actually be seen as its own state being resolved. I generally like to keep sketchbooks of unresolved drawings as I personally prefer them because you can see what you are learning from each image.

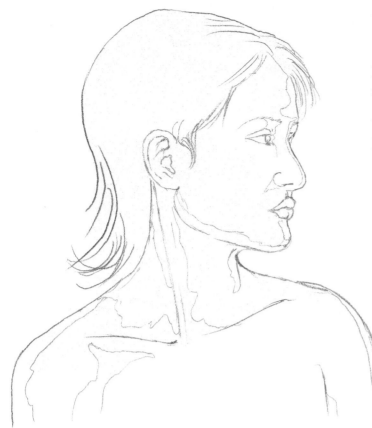

In the third image the outlines of the shadows have been indicated using a light but confident line.

In the fourth image tone is beginning to be applied and blended across the face. This stage may look strange but keep going! You always have the putty rubber to help.

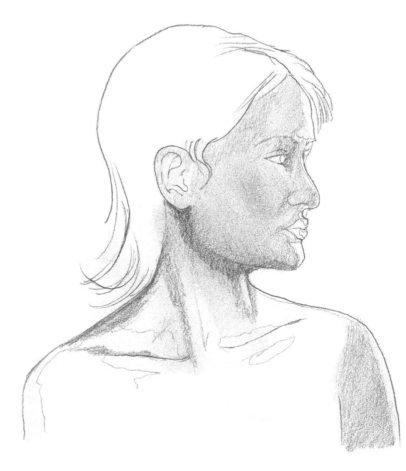

In the fifth drawing you can see how the tone is now less flat as more tone has been hatched and cross hatched into the jawline, neck, around the eyelid and around part of the eye socket and nose.

In the sixth image the hair is being developed with a soft pencil: 3B–7B all work. 3B will stay sharp for longer as it is harder than 7B so you can use a harder, lower number for flyaways. Tonal range has been developed on the body as well as the lips, eyes and brows. A putty rubber has also been used to lift off areas of tone on the forehead just between the brows where light reflections were the most intense.

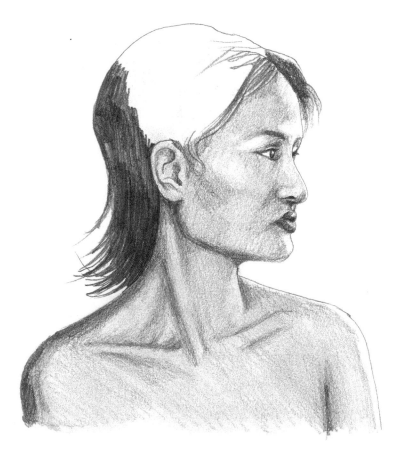

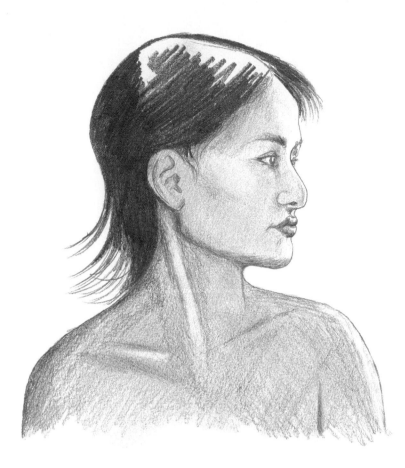

Sometimes you may need to go back and forth, adding tone and taking it away and adding it and taking it away, which is why it is good not to press too hard with your pencil. In drawing number seven you can see how some of the tone on the forehead has been filled over. This was just blended over.

In the eighth and final drawing you can see that the nose has more light on it, and the forehead too.

Eventually the image will begin to make more sense to you and you will understand which direction to take it in depending on the interplay of light and shadow.

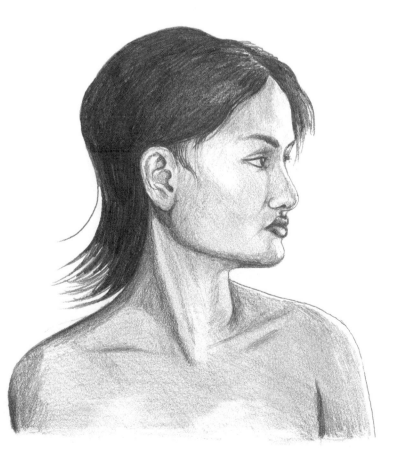

BACK AND FORTH WITH TONE AND THE PUTTY RUBBER

Textiles, particularly sheer or illuminated textiles, can pose an interesting challenge. This model was wearing layers of underwear to create an artistic and stylized pose. The stockings were sheer but very reflective.

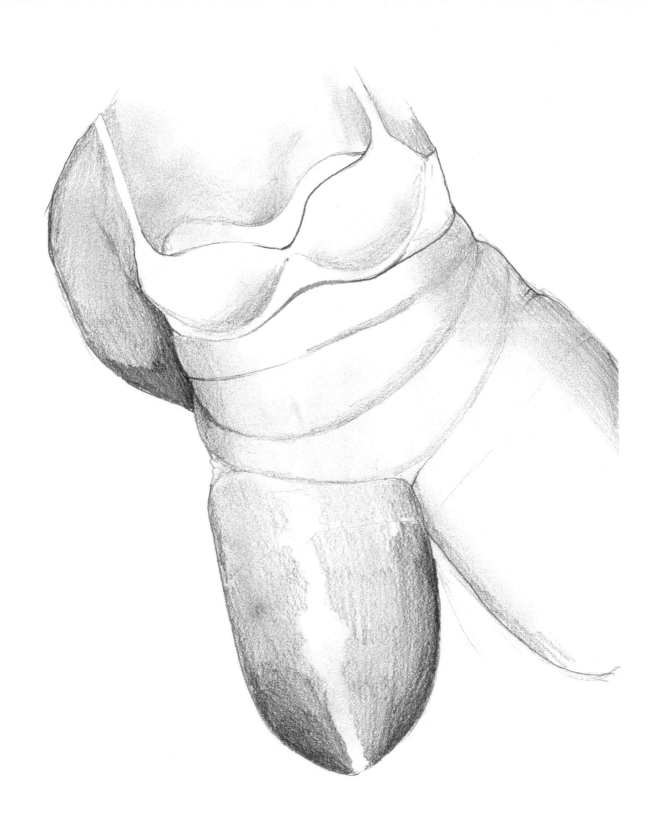

Hatching and blending are used to shade in the figure. Graphite stick and HB pencil were chosen to do this.

Lines are lifted away using a putty rubber, and more blending takes place.

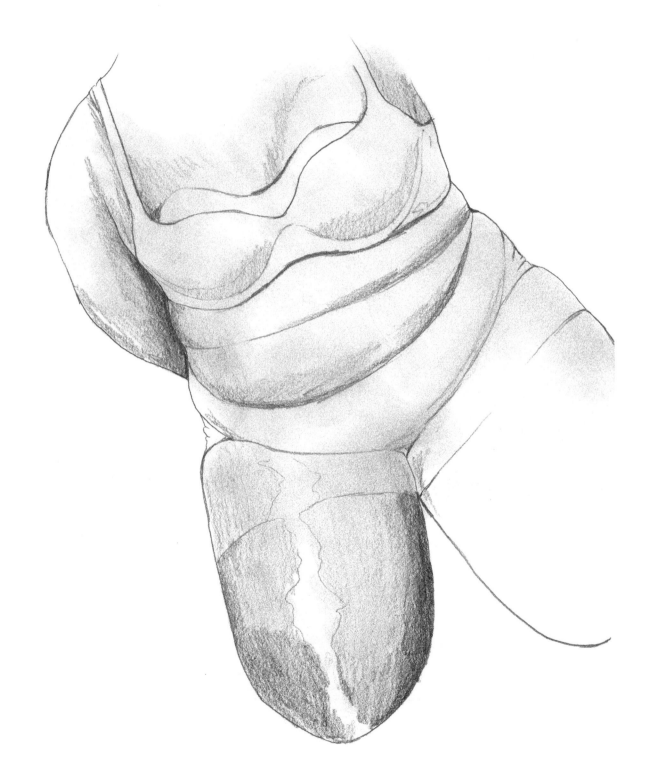

Emphasizing the reflection on the stockings, and playing with it by going back and forth with the putty rubber and pencils, eventually leads to something expressive and lively.

POSTURE AS IT RELATES TO GAZE, TILT AND SPINE

The next chapter focuses on gaze and expression, but all the chapters interconnect and are related to each other. Posture informs the pose, which is informed by tilt, which is determined by the gaze or direction of the head.

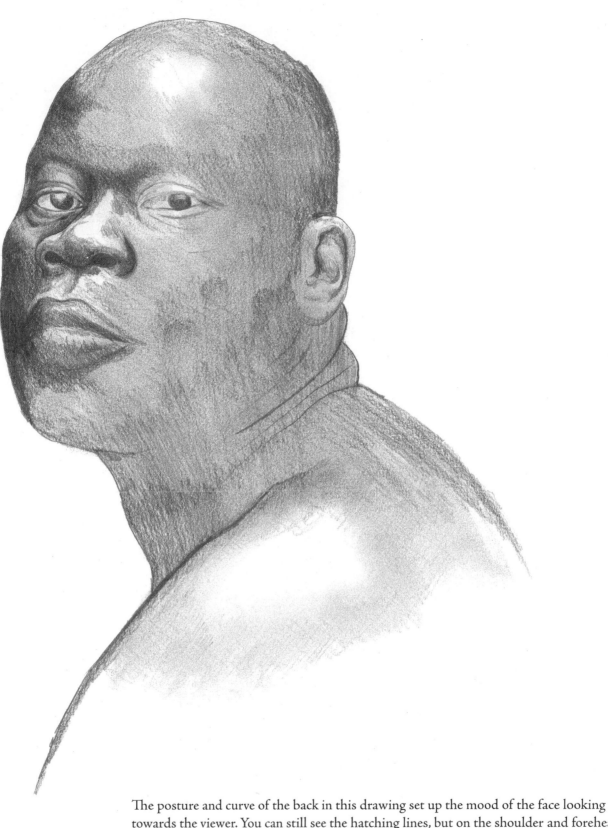

The posture and curve of the back in this drawing set up the mood of the face looking towards the viewer. You can still see the hatching lines, but on the shoulder and forehead you can see a more blended, smudged tone. This variation in texture makes the image look dynamic and as if some parts are in and out of focus.

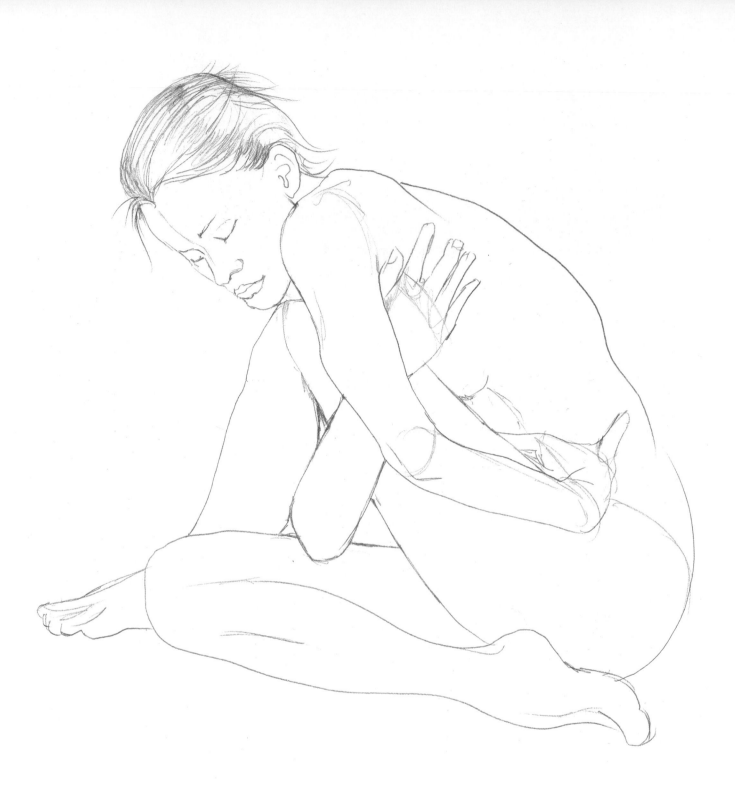

This drawing is of a more complex but poetic pose. The model's left leg is crossed over the right, which is folded under the left hip. The model has their right arm under their left leg, almost in an embrace, and their left hand on their hip with the left shoulder facing us.

Contour and varying line weight was very important in ensuring that this image made sense.

The attitude and mood of this pose is very powerful. The front-facing shoulders and crossed legs, with the hand casually on the lap and another held up and folded, create an interesting dynamic of strength and calm. The model's head is tilted down and they are looking directly at the viewer, so the eyes look up almost from beneath the brows, creating quite a firm facial expression.

Tonal techniques have been applied to parts of the body and to the hair. The construction lines of the face remain in place.

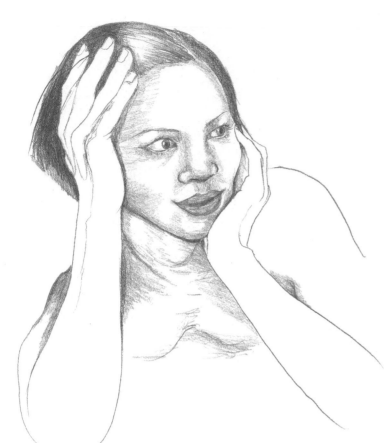

These examples show two very different poses. In the tonal drawing we see the model look to their left, right hand on their head holding hair out of their face and their elbow propping up the head and shoulders. The left hand is more casually cupping their face with the elbow on the table too. The gaze is indirect, but the narrative of the pose is still quite intense as we wonder what the figure is looking at.

In the line drawing the figure is leaning over so that we can see the back of their head and their arms, shoulders and back. The lighting was very intense in this sitting and the shadow and light contrasted strongly. The contrast between light and dark is indicated with the line. Try to imagine what the drawing would look like with tone.

In this drawing the slight foreshortening, tilt in the head and shoulders and twist in the spine all combine to create a pose that appears to be in mid movement. Drawings that look as if they are almost moving can hold a lot of narrative. Try to imagine what the model does next: are they reaching behind them for something? Or are they about to stand up?

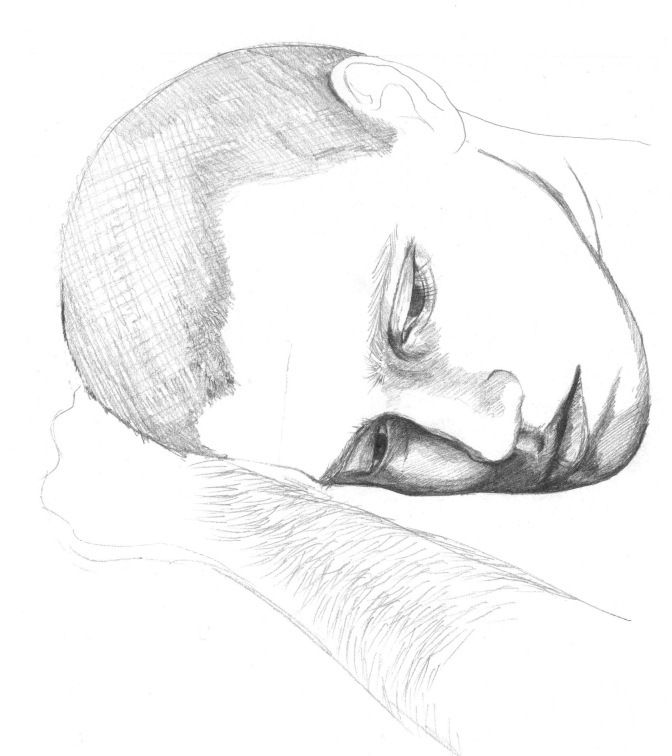

Pose and posture can be captured by focusing on any part of the figure. It doesn't have to be the whole body or the torso. In this image the focus is on a reclining figure lying on their front with the head facing the viewer and resting on their hand. We can see their forearm and head. Try to describe the pose and posture of the model, as it helps you interpret it and think where to place construction blocks when you are creating a drawing.

A great deal of narrative and attitude can be communicated through profile alone. While the egg and ball shapes and ellipses were used in this study, they were promptly lifted out to create a more striking image which works well with tone and mark making sparingly used on the earring, eyes, mouth and hair. The main drawing element I used is line weight to vary depth.

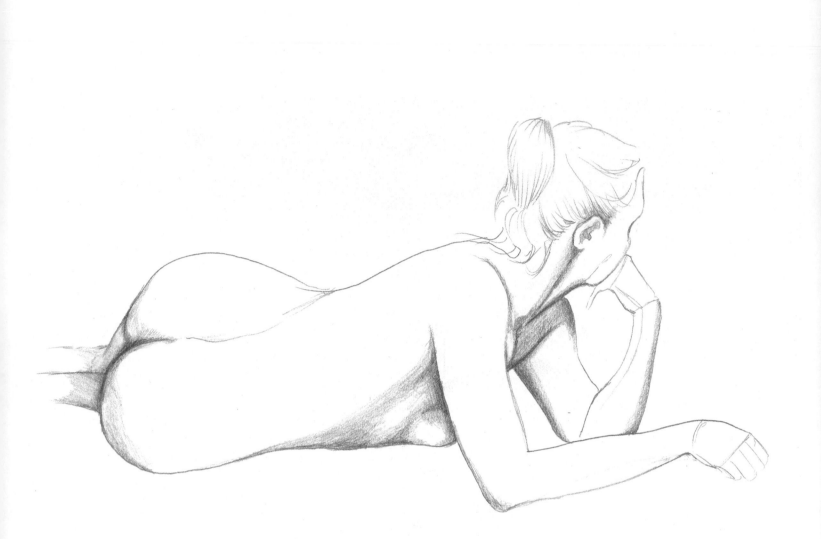

This reclining pose uses tone sparingly to simply capture some of the shadowy areas of the drawing. Construction blocks are still visible in the hands.

In this example we return to a step-by-step sequence. This is an image of a model taking a picture of themselves in the mirror, or it could be directed at us.

In this drawing tonal differences have been sketched out.

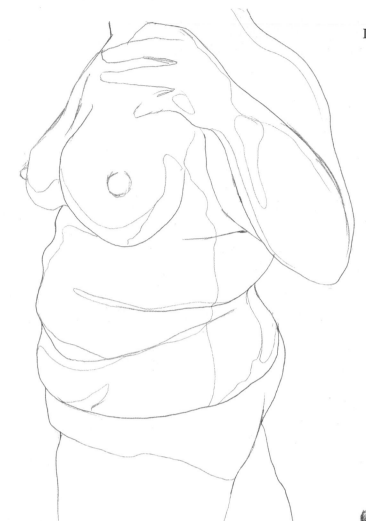

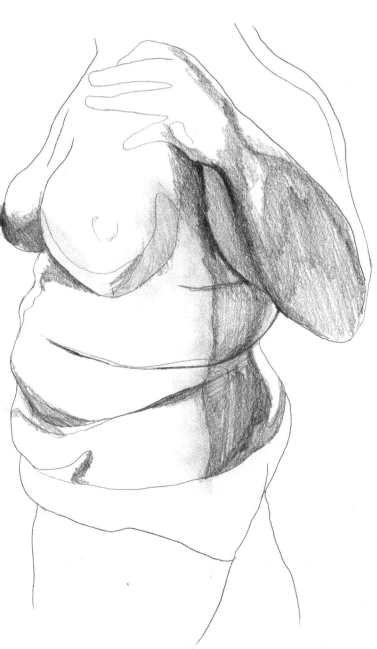

Shadow is introduced using hatching. More intense hatching is included in the folds and creases where the arm meets the body.

Tone is being distributed across the body to create a sense of volume and depth. Some blending has been used but mainly hatching and cross hatching. Highlights have been created by not hatching in places.

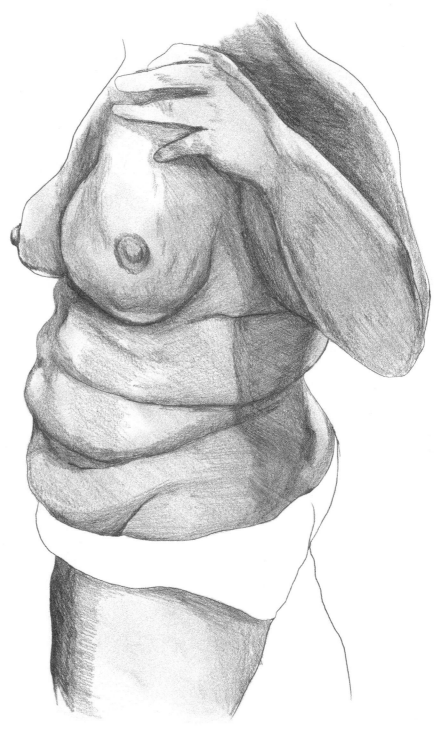

CHAPTER 6
GAZE AND EXPRESSION

Expression can be difficult to capture, and involves the whole face and the pose and posture of the figure. Gaze operates a little bit like pose: it is about the direction that the face is looking in and is most often associated with the eyes. Gaze communicates a mood and narrative element in figure drawing and portraiture. Expression can be captured in great detail and hold a lot of potential for narrative in an image when we consider the gaze.

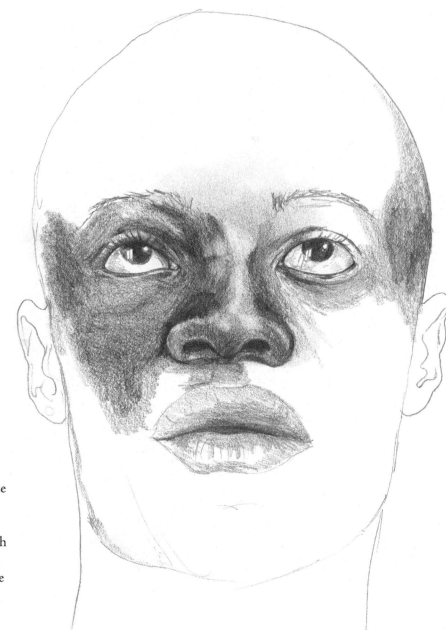

In this example the direction of the gaze contributes to the mood and narrative of the drawings. The shadows and reflections on the eyes were created with a hard pencil and putty rubber, so that their watery reflective detail become the focus of the image.

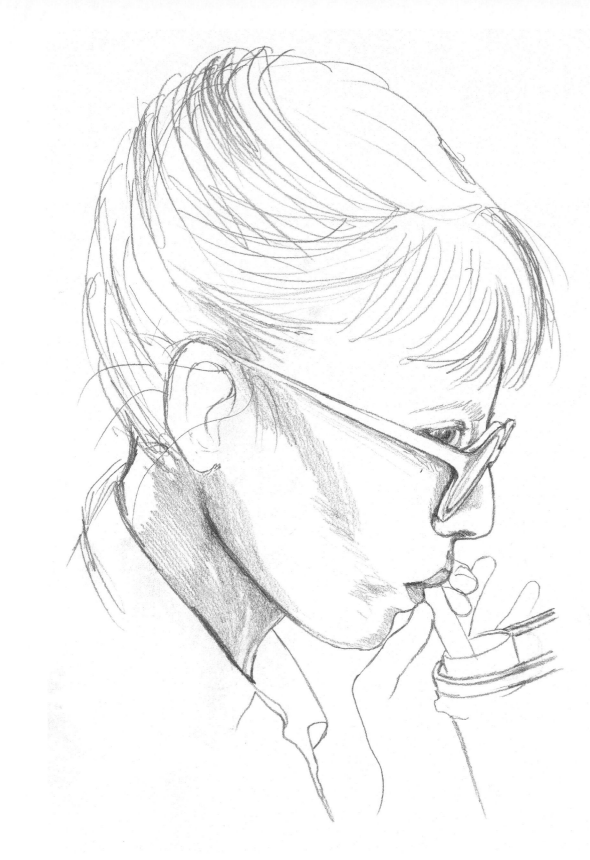

Here the eyes themselves are quite hard to see: they are obscured by glasses and we can only see the top of one eye. Nonetheless narrative and 'a moment' has been captured.

LAUGHTER, CONVERSATION AND EXPRESSION

The marks and tones used in this drawing can be seen next to the drawing. Laughter is quite difficult to capture. Sometimes when directing the model, if you have consent, you can take photographs to use in drawings later. I find it much easier to engage the model in conversation and to direct their gaze somewhere else in the room or space and allow the natural flow of conversation to guide expression so that I can capture facial expressions in the moment.

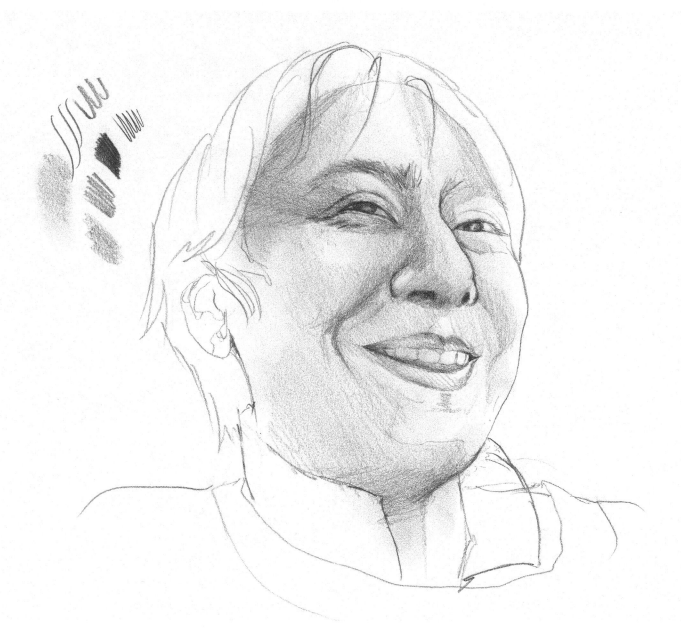

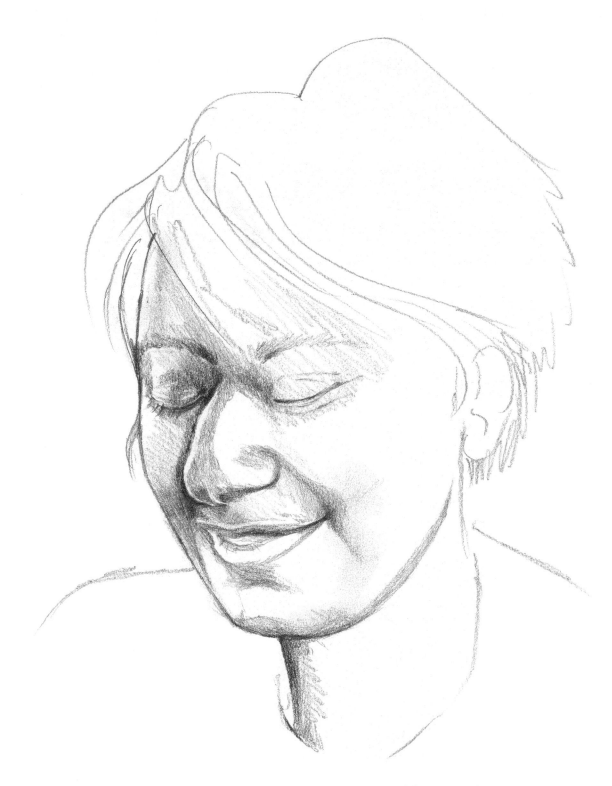

The gaze in this drawing is looking down.
Expression is carried by the head tilt and mouth
in mid sentence.

EMBRACE

The sketch captured two figures looking at each other.

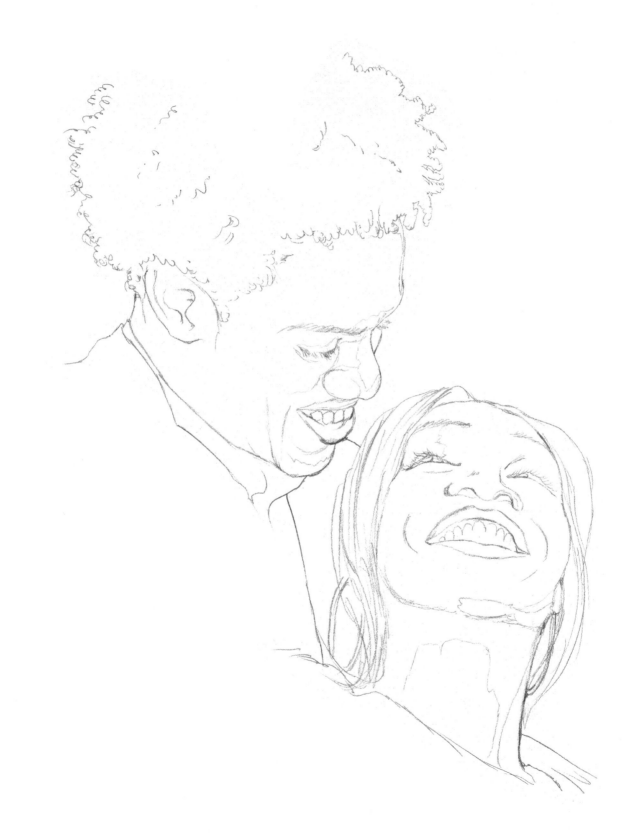

When adding shading and details you can decide to focus on specific parts of the face engaged in narrative and expression.

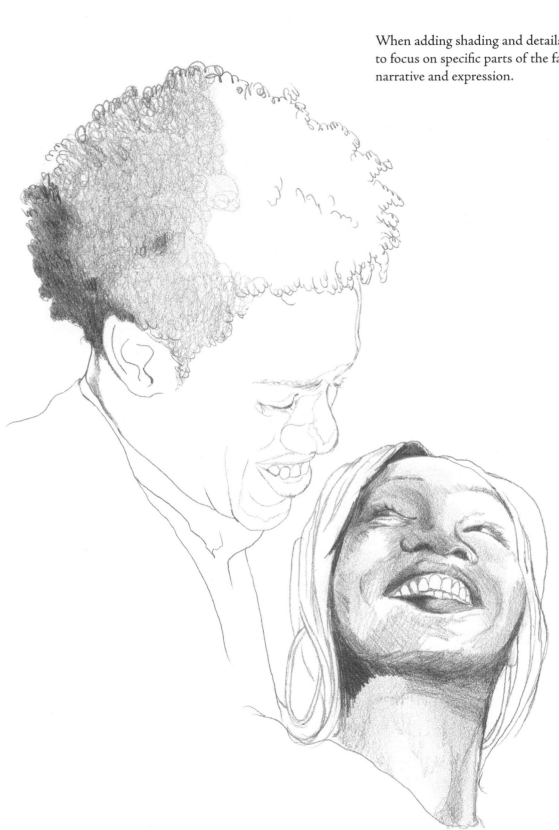

GRIMACES AND SCOWLS

Facial expressions vary greatly. A grimace can be very hard to capture and requires a very light touch with texture, mark making and tone to capture the wrinkles and laugher lines and creases that we see in the face in expressions such as grimaces. Try not to overdo it as they can look 'forced' very easily.

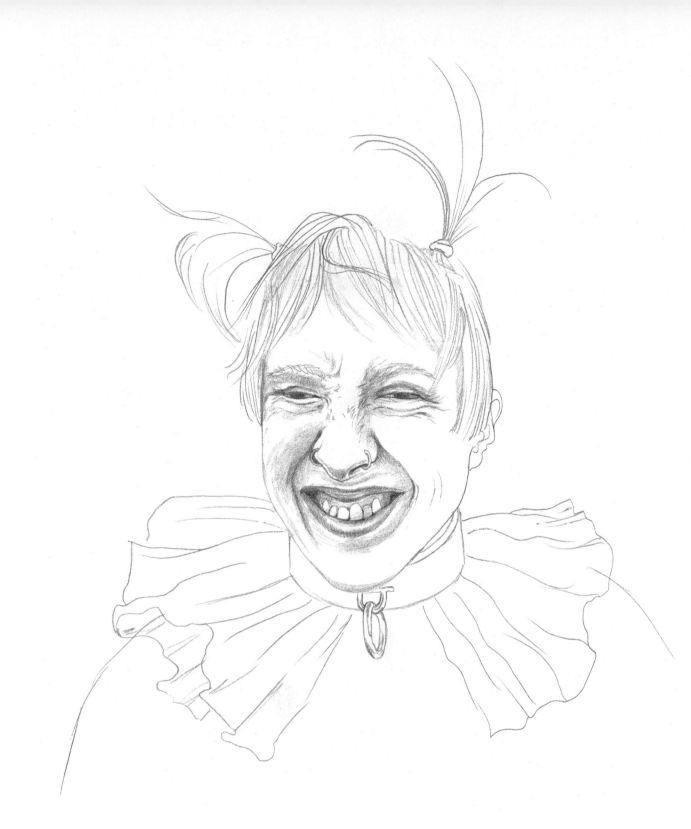

Sometimes a grimace will make it hard to see any detail in the eye. I find it helpful to draw it in anyway and then shade over the white of the eye slightly.

SMILES AND TEETH

Treating the mouth and teeth and eyes with as much attention as you would the whole body or the hand makes it possible to capture depth, details and personality in expression. The gaze in this image is looking towards us, and the eyes as well as the teeth have been treated with subtle shadows and points of reflection created using a 4H pencil pressed very lightly and a putty rubber to smudge and lift graphite layers. Avoid smudging when introducing details like this as it tends to flatten a drawing.

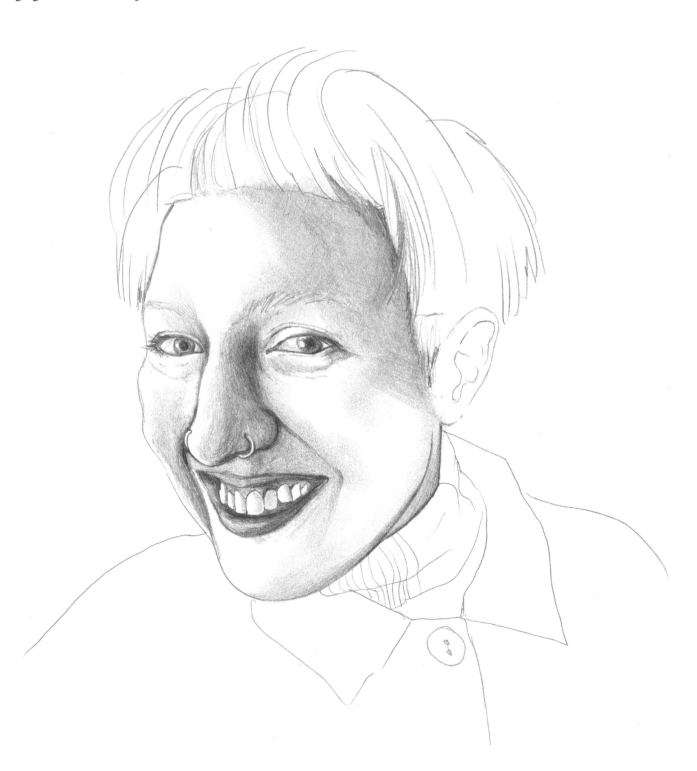

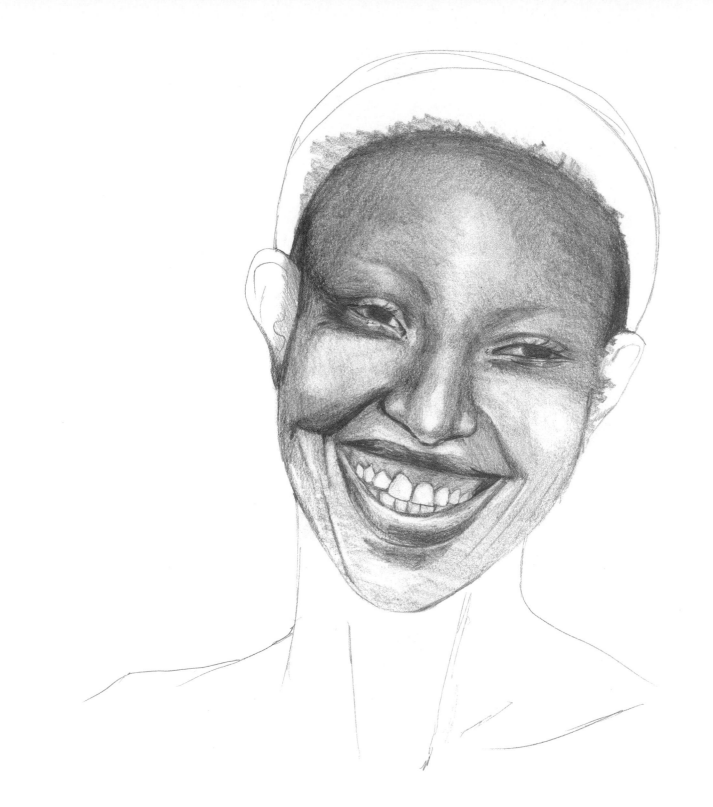

Similarly, the white of the eyes and teeth has been shaded lightly in this drawing.

LOOKING TO THE SIDE

Even when the gaze is not directed at the artist/viewer it is still possible to create a very personable drawing.

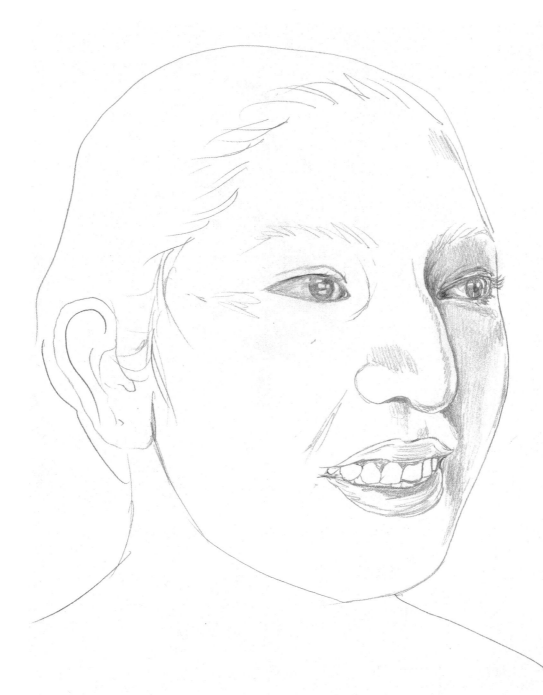

The figures in this drawing all have an indirect gaze which helps to maintain a sense of narrative and expression.

EXPRESSION

In this drawing, graphite and a combination of blending and hatching has been used. The hatching has been blended in places but not across the whole face.

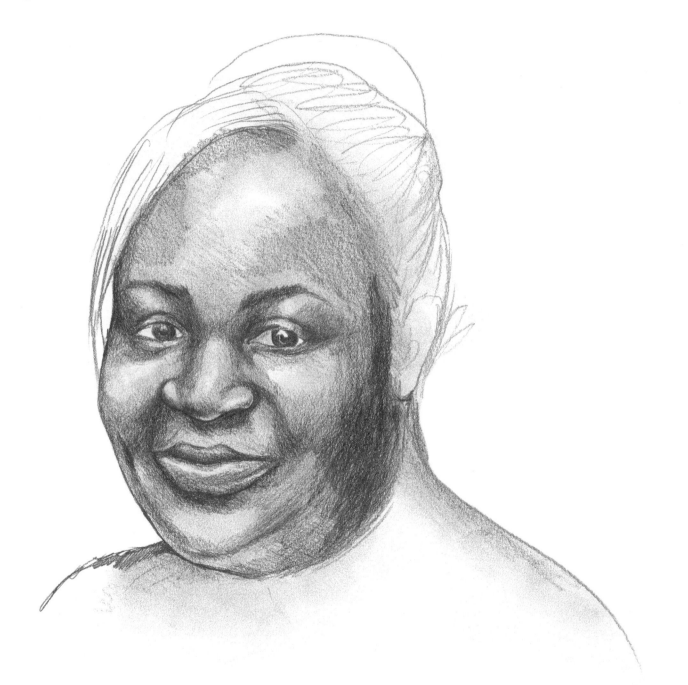

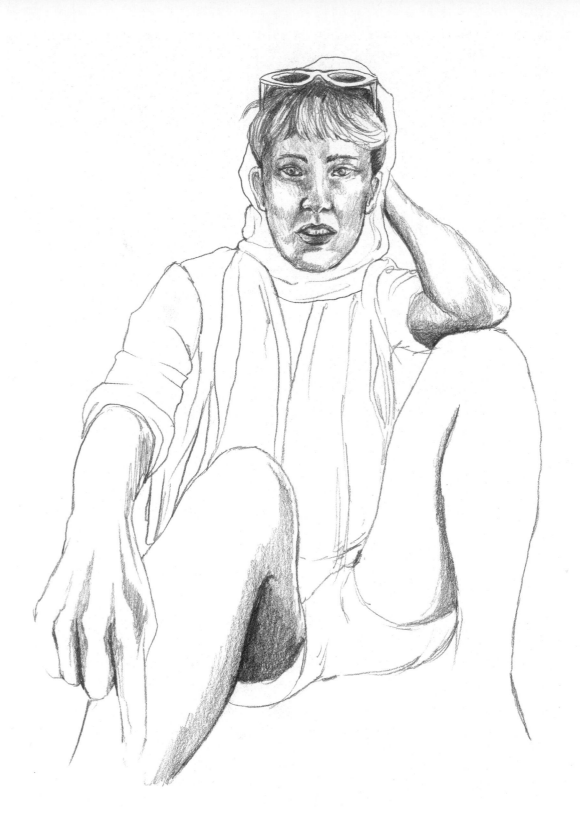

Expression is held in the pose as well – which, as we know, can communicate mood and narrative as much as the gaze and expression. Try to think about how they work together. In this image the foreshortened folded leg has some tonal details included but most of the detail is in the face and arm. This is to show different stages but it is successful in developing emphasis or focus in a drawing.

GLASSES

Many people wear glasses for reasons of health, need, disability or apparel. They can be quite tricky to draw and should be treated like any other 'structure', by using construction lines, simple shapes and ellipses.

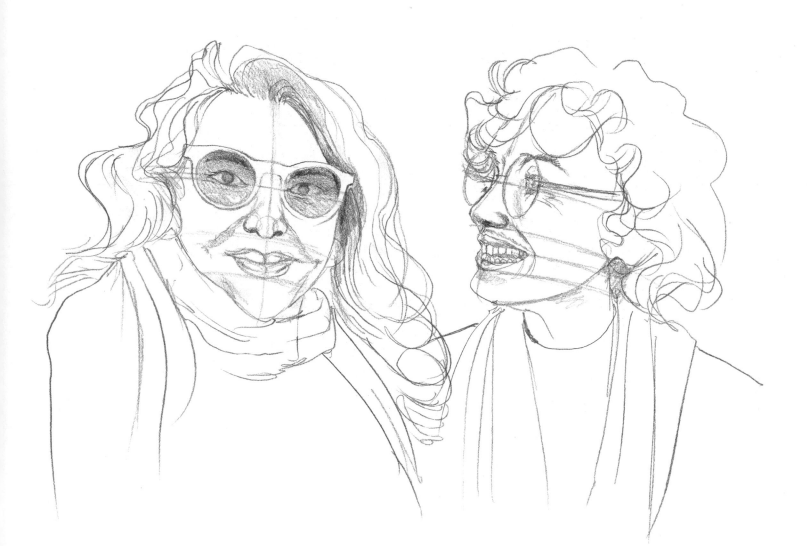

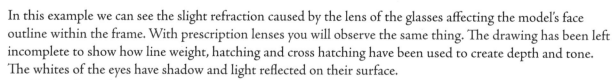

In this example we can see the slight refraction caused by the lens of the glasses affecting the model's face outline within the frame. With prescription lenses you will observe the same thing. The drawing has been left incomplete to show how line weight, hatching and cross hatching have been used to create depth and tone. The whites of the eyes have shadow and light reflected on their surface.

To develop a drawing further you could blend the pencil marks and build more pencil marks on top. You could use the putty rubber to show light reflecting on the skin's surface. The fact that pencil marks are visible is not a problem, it is after all a drawing and the material and processes that created the drawing being visible is part of the artwork.

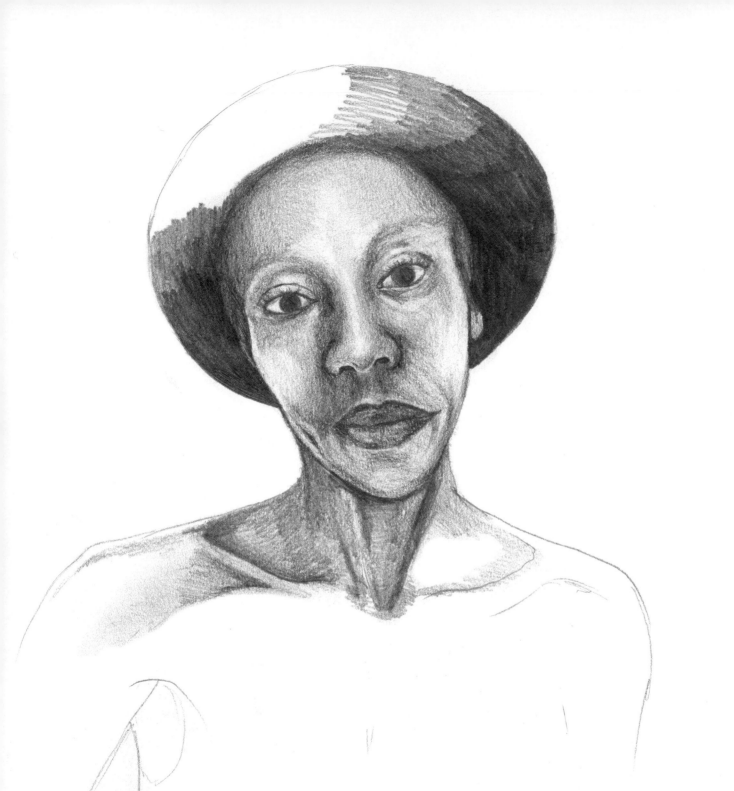

HAT

Accessories, jewellery and clothing are also part of our expression. You can choose whether you want to focus on clothing or not, but every now and then creating a study that focuses on accessories and glasses can help expand your skills.

HEADSCARF

Including a headscarf, which can be a very important cultural and fashion item, has been done loosely with contour in this drawing. Pattern and tone can be applied later. Be aware of how a headscarf, glasses or hat creates shadow on the face.

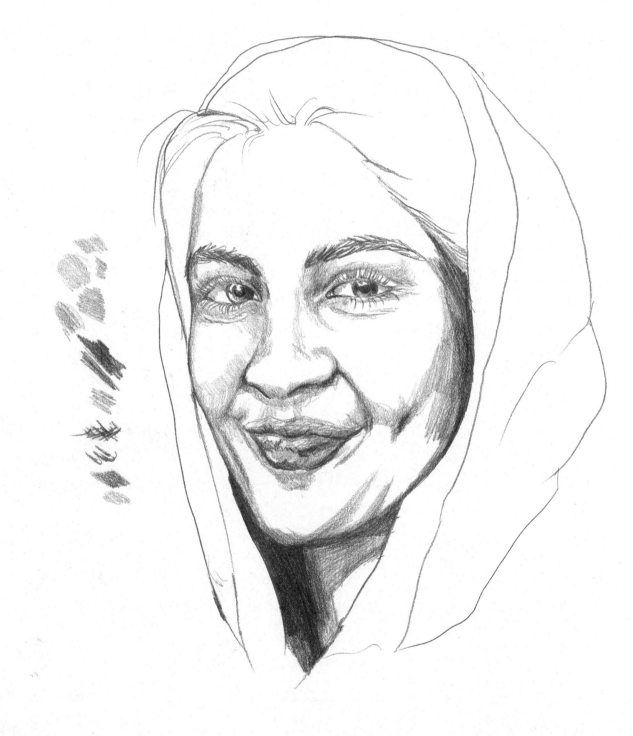

HAIR AND EXPRESSION

We have will look at hair in the more detail in Chapter 8. It tends to get overlooked in life drawing but is worth more attention. Hair is an important aspect of human self-expression so I have included some examples here.

In this example (like many of the others so far in this book) I have used a shorthand or quick version, simply employing scribbles and lines. This can look quite messy but can be returned to and built on later.

The hairline is important because it tells us a lot about the shape of the model's head, forehead and eyebrows, and their personal style. The outline has briefly been scribbled in to show where it begins and ends. Try experimenting to include a contrast of resolved image in the eyes and mouth and more rushed expressive sketching in the hair.

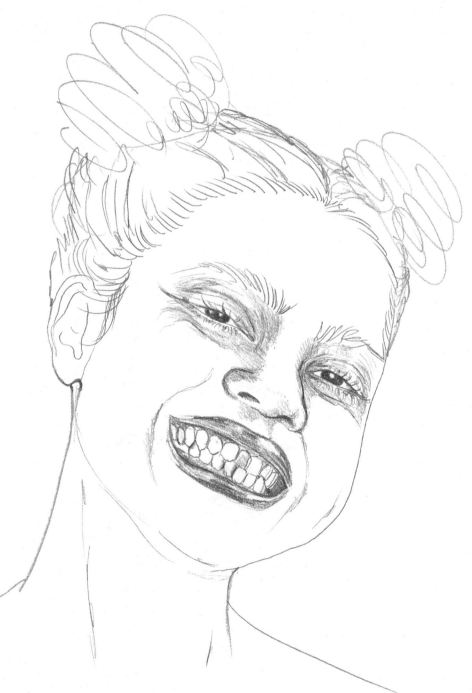

HAIR TIED UP

In this image the hair has been filled in more thoroughly but not completely, to show stages in drawing. Line weight is also important to capture the depth and texture of hair.

CHAPTER 7
ACTIVITY AND MOVEMENT

One of the most crucial things to attend to in capturing activity and movement is how weight is distributed in the figure. It is like an extension of pose as you want to capture a mood or moment.

Try initial experiments with blocks and contour. To create movement in the hair I have sketched it as moving in the same direction, flowing slightly behind the figure. This can be enough to create the sense that someone is in motion.

In this drawing the figure is arched backwards; both sketches of the model in motion in various other poses and using a photo were needed to develop the drawing.

REST AND CONVERSATION

This study was carried out while the models were engaging in conversation.

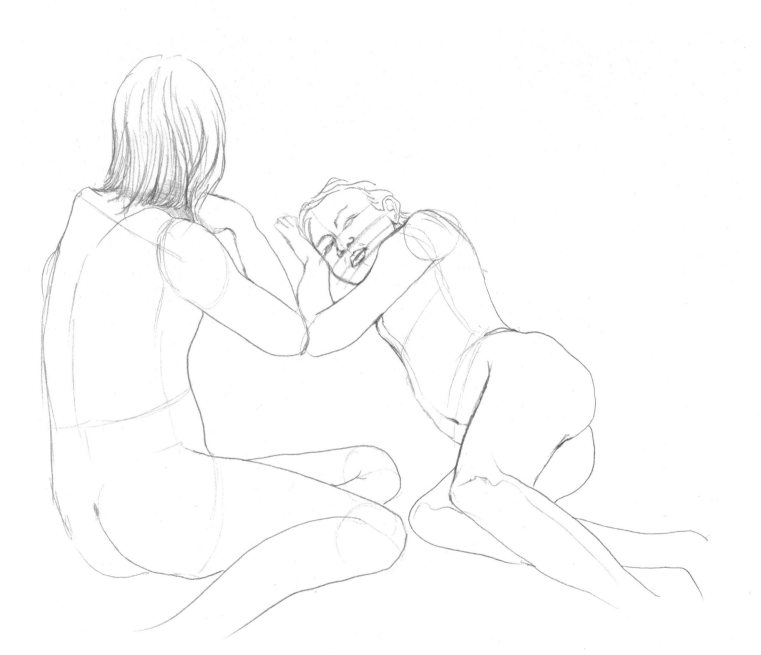

SLEEP

Drawing the figure at rest can create endearing and gentle images that, much like pose and posture, contain a sense of narrative and personality.

WEIGHT DISTRIBUTION

When the figure is in movement, weight distribution varies across the body. A closer study of anatomy and recognition of what muscles and ligaments are used in different movements and noticing them in the figure can help you accentuate them, which creates a more convincing drawing of movement in action.

COMPLEX POSES

In some poses, the figure might be in a pose that seems unnatural. It's actually fun to lean into this. In this drawing the shadow around the face was exaggerated and the squashed quality of the skin on the cheeks was meaningful.

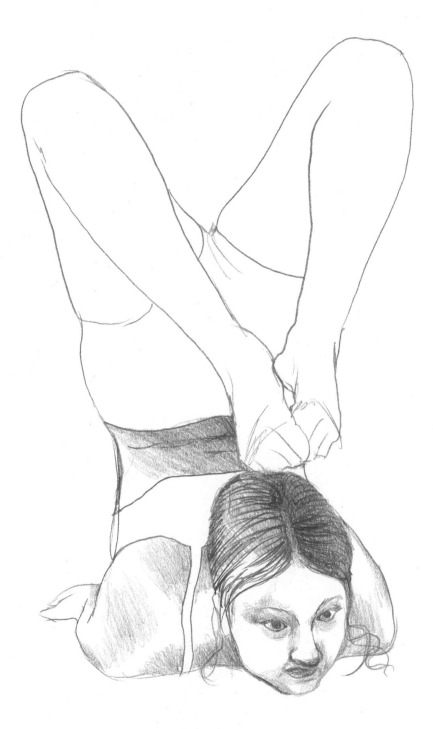

FORESHORTENING

In this pose I had to add extra shadow on the model's right shoulder blade, as there is a twist in the spine and their shoulder was obscured by their head. Adding some extra tone on the right shoulder made this complex pose make more sense. Sometimes it is necessary to use artistic licence in this way.

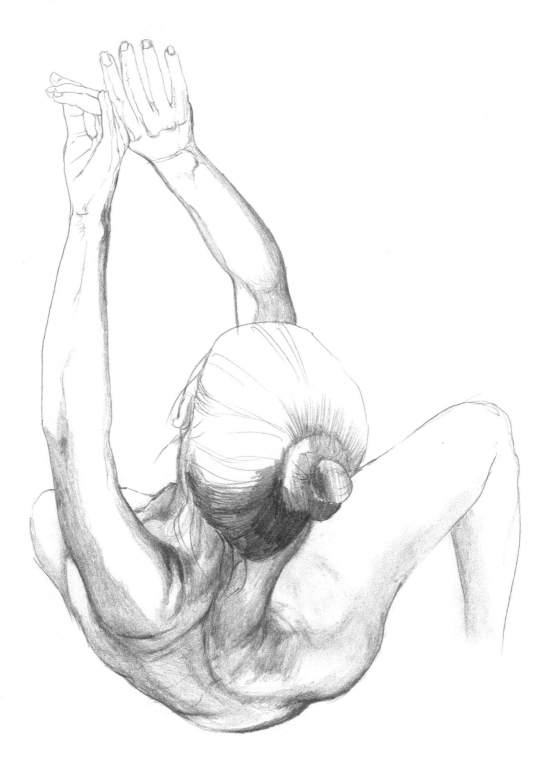

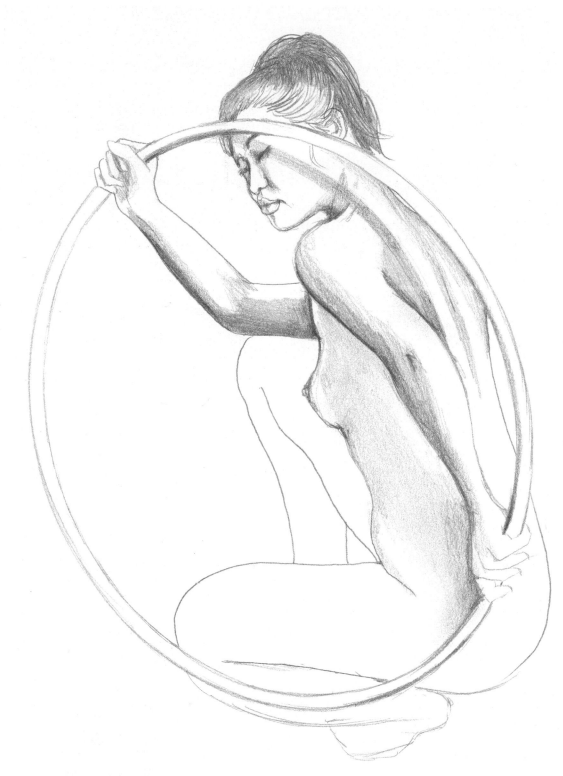

HOLDING A HOOP

In this drawing the object being held by the figure is part of the pose and narrative. Textiles and objects may be important in the narrative of a drawing. The hula hoop created a shadow that was curved and graphic. It was important to pick out this detail so it didn't look as if it was a shadow caused by anatomy. The hoop's shadow across the face helps to emphasize the arc it creates.

HOLDING ICE CREAM

In this drawing the focus was not the ice cream but the bend in the wrist and the shadows on the skin. Sometimes details like objects and textiles need to be emphasized and sometimes they need to be simplified. You get to make the call.

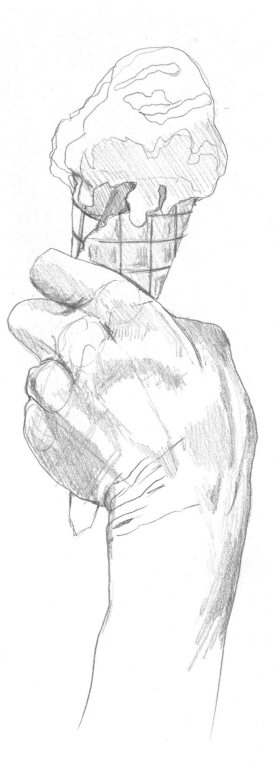

IN THE BATH OUTSIDE

In this drawing the model is sitting in a bath outside. The bath is in perspective and the waterline has been sketched in. Some of the details such as shadows in the bath, the tap and plug chain were removed to simplify the shadows. This way the details of the bath didn't distract from the figure, which in this drawing was necessary.

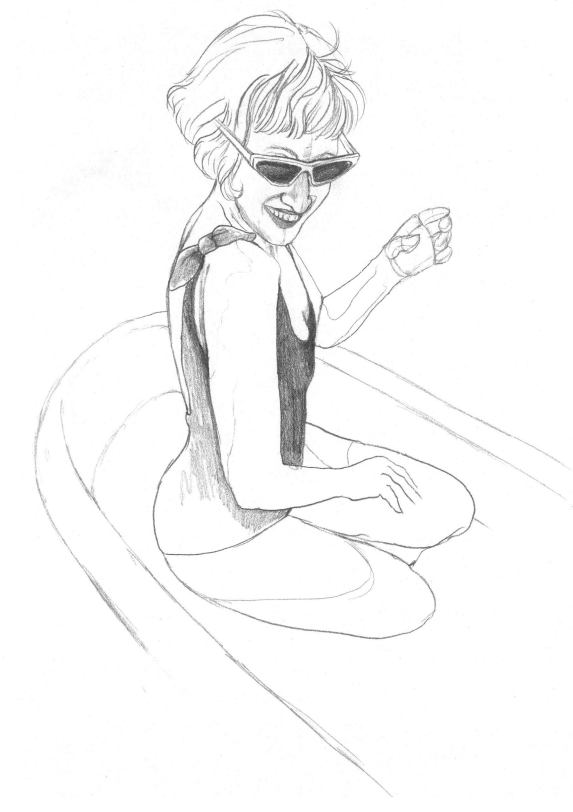

STEPPING UP

In this pose the model was shifting their weight from one foot to the other during three-minute repeat poses. This was deliberate as it is not a very comfortable pose and it also meant that the drawing itself had to 'settle'. Using a varying line weight made it easier to create a sense of motion. In this drawing you can still see the blocks used to create the figure.

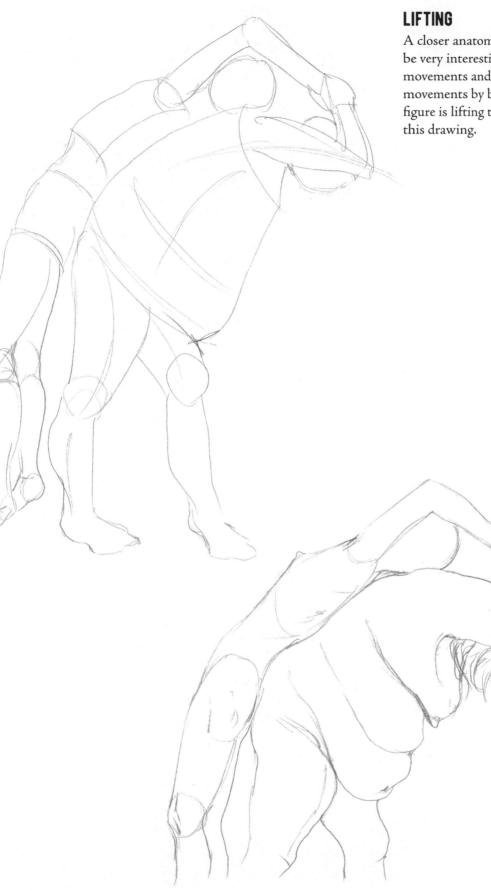

LIFTING

A closer anatomical study of this would be very interesting to discuss muscle movements and how we can capture movements by being aware of them. One figure is lifting the other over their back in this drawing.

GETTING UP

In this drawing the weight distribution is subtle but communicates narrative in the image.

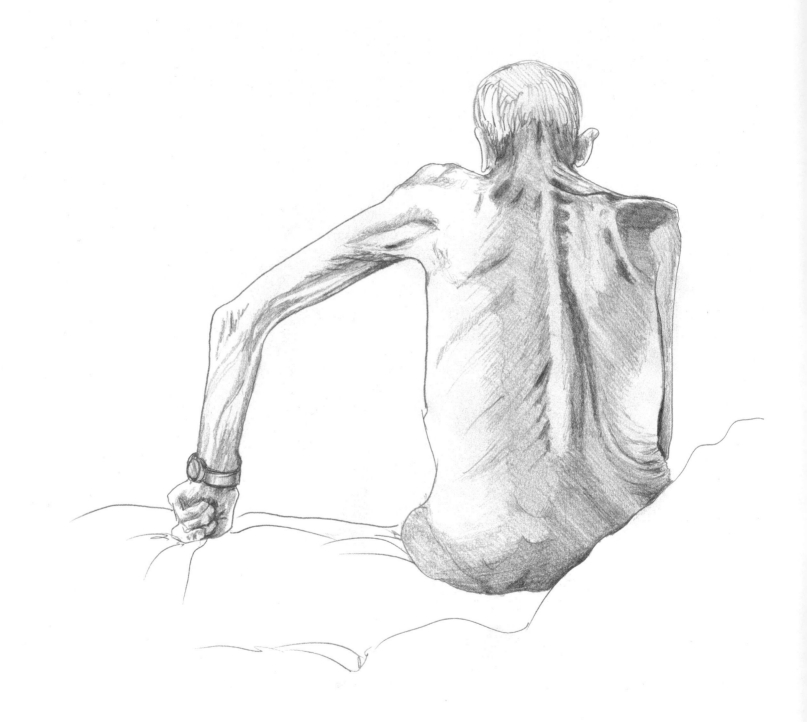

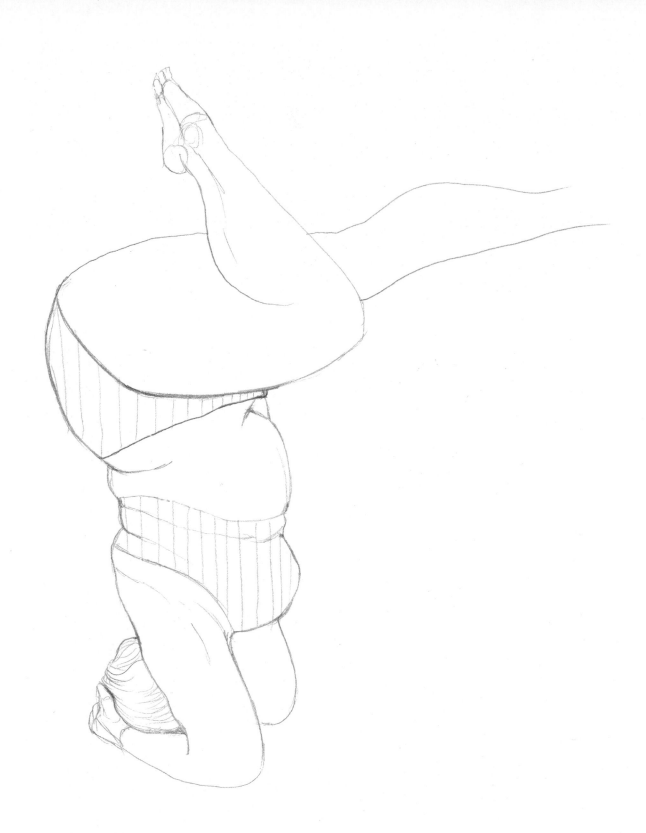

HEAD STAND

In this drawing the textiles have been drawn with parallel lines to create an interesting and contrasting graphic effect against the curves of the figure. The folds of the skin communicate a lot about how the model is holding the pose and again we gain a sense of movement from this.

DETAIL, SKIN AND HAIR

In this chapter we look at developing details. Many of the details covered in this chapter have at least been touched on in others but the focus here is on resolving an image and using mark making to capture the details and textures of the skin, hair and face.

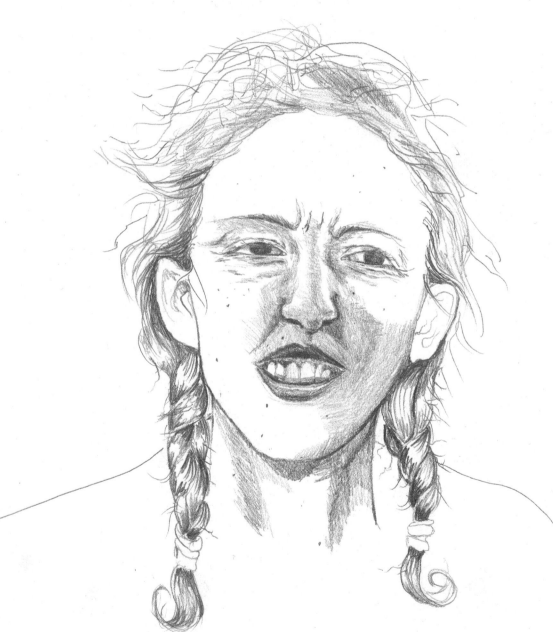

MARK MAKING

Mark making is an important technique to draw on in the more final stages of a drawing when you are trying to capture the finer details of the individual.

Shadows, reflections, reflections within shadows, creases and hair texture will be touched on in this chapter.

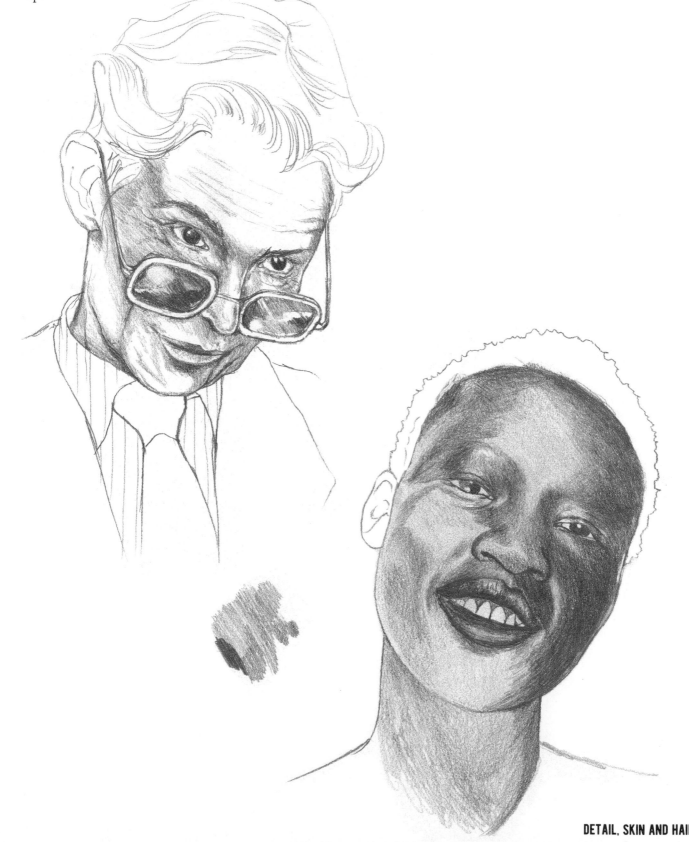

BUILDING FORM AND TONE

Begin with the head using the egg and ball. Here we can only see the egg because it is facing completely forward.

Then add the lines for the eyes, nose, mouth and middle of the face.

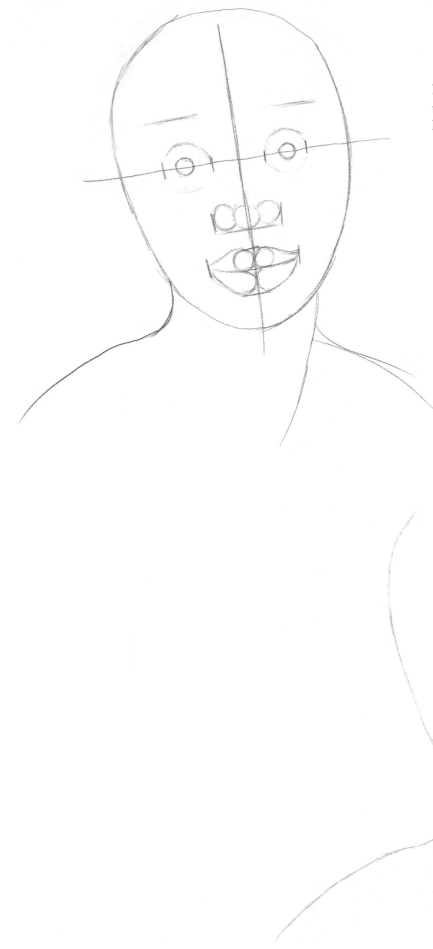

Next develop the shapes of the eyes, nose and mouth using circles and contour. Remove the construction lines.

Following this, contour was used to create the shapes of the eyes, nose and mouth. The drawing is beginning to look more like a person.

Remove the construction lines, circles and ellipses.

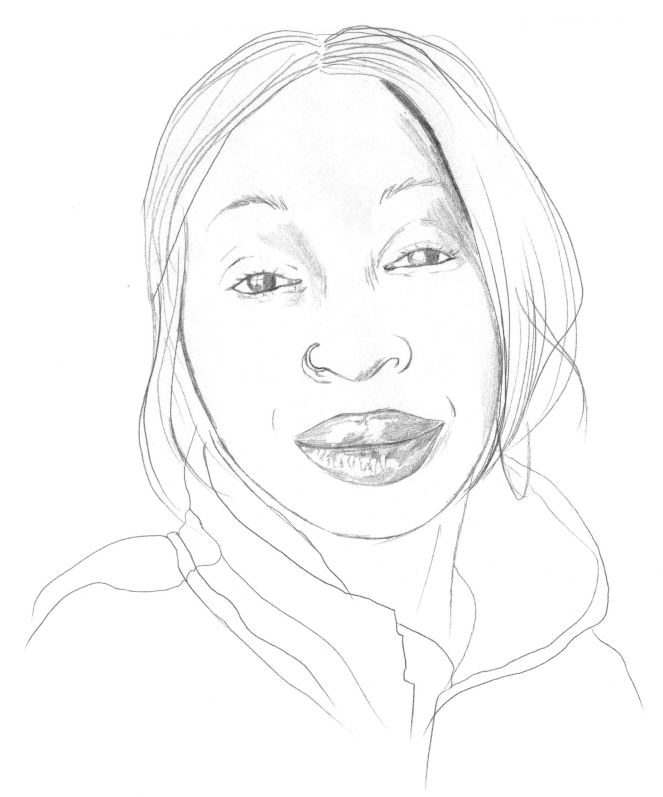

Begin introducing tonal range using hatching.

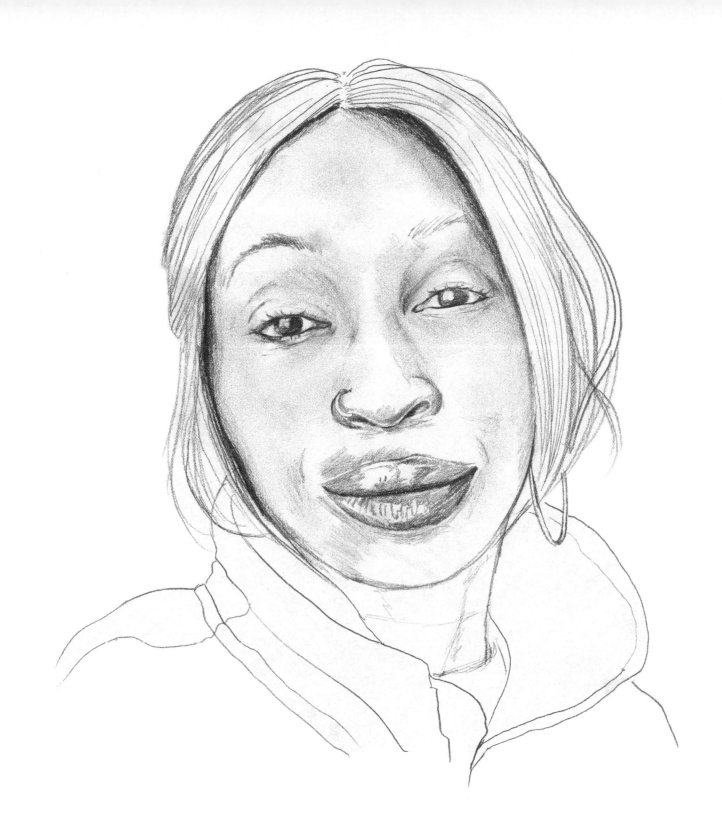

Add tone to the eyes and lips and begin building up details across the drawing. Don't focus in one area alone, lift the whole drawing up together.

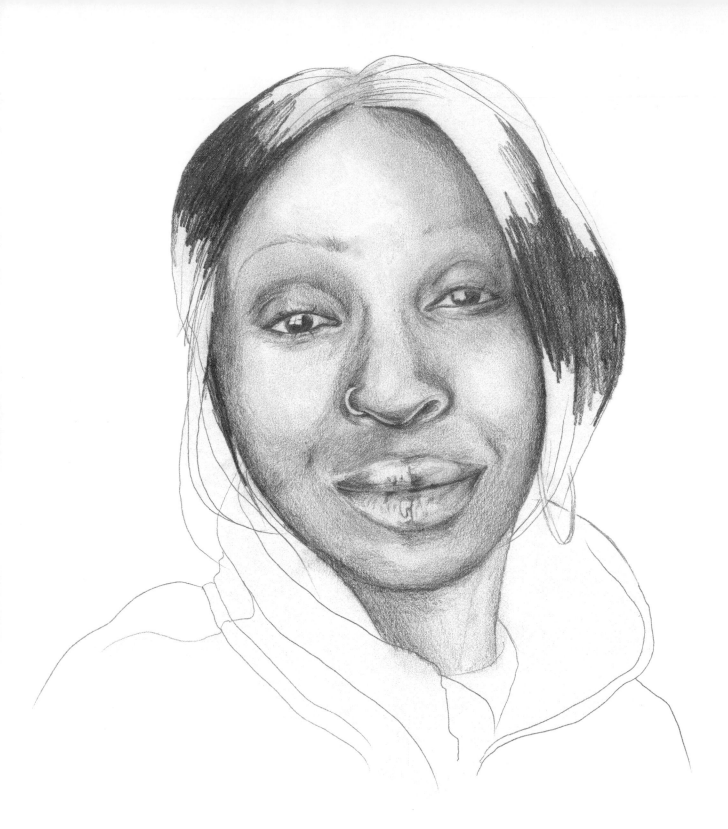

In this stage we see the whole drawing except for the clothing is being gradually completed.

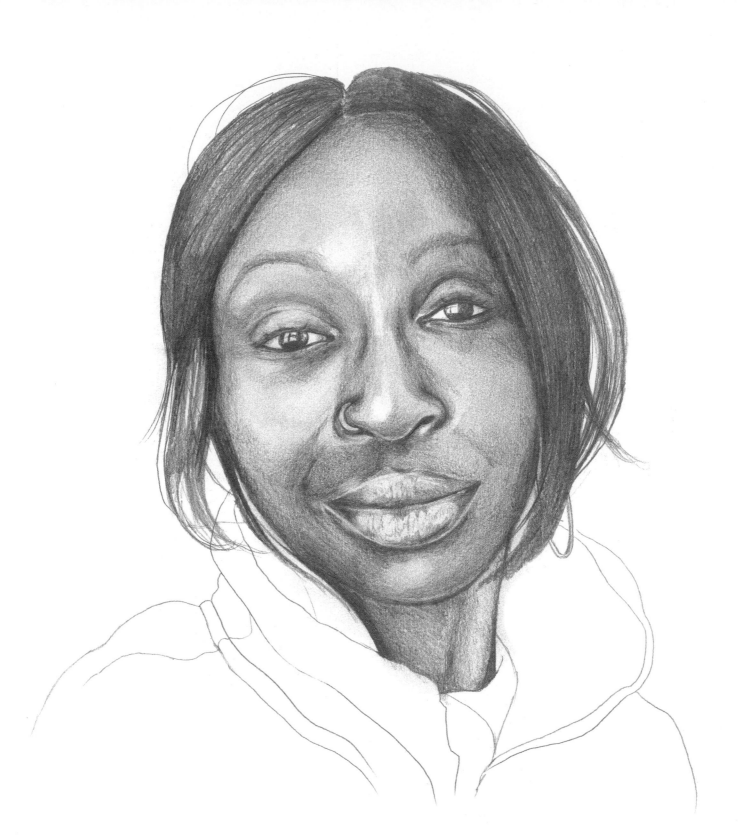

In the final stages of the drawing process, build up more tone and complete the hair. In terms of mark making for the hair in this drawing, I made the marks I created match the direction and texture of the hair.

HAIR AND BROWS

Details of the hair, eyes and brow have been completed with dots and dashes. I have included a swatch of mark-making textures and patterns that have been applied to the drawing.

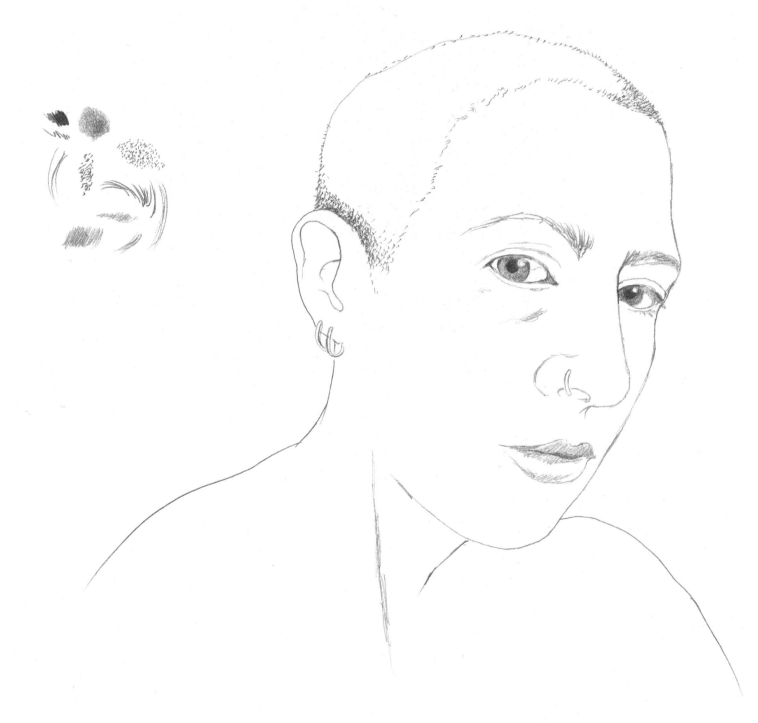

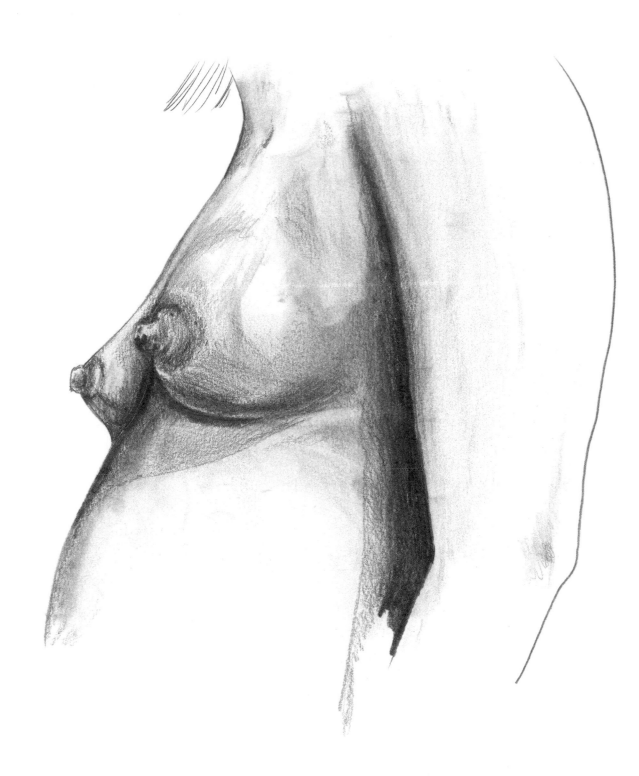

REFLECTION WITHIN SHADOW

Light reflected beneath the breast in this image was important to capture the texture of the skin. Keep an eye out for reflection within shadow.

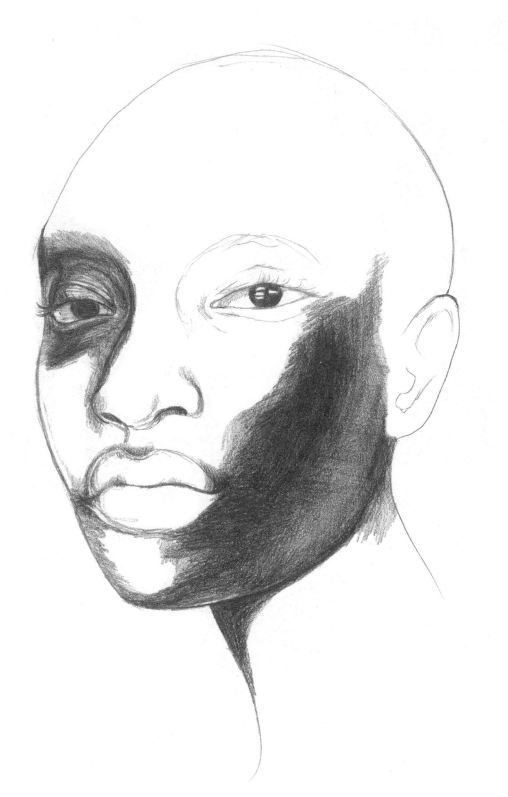

REFLECTIONS IN THE EYE

This drawing is partially complete, to show the different tonal qualities applied. When applying tone, build it up, do not go in all at once. The eye has been detailed with shadow and reflected-light details.

LIGHT AND SKIN

In this drawing, hatching, blending and putty rubber have been used to create the illuminated surface and shadows on the skin. Dots have been used to draw freckles on the face.

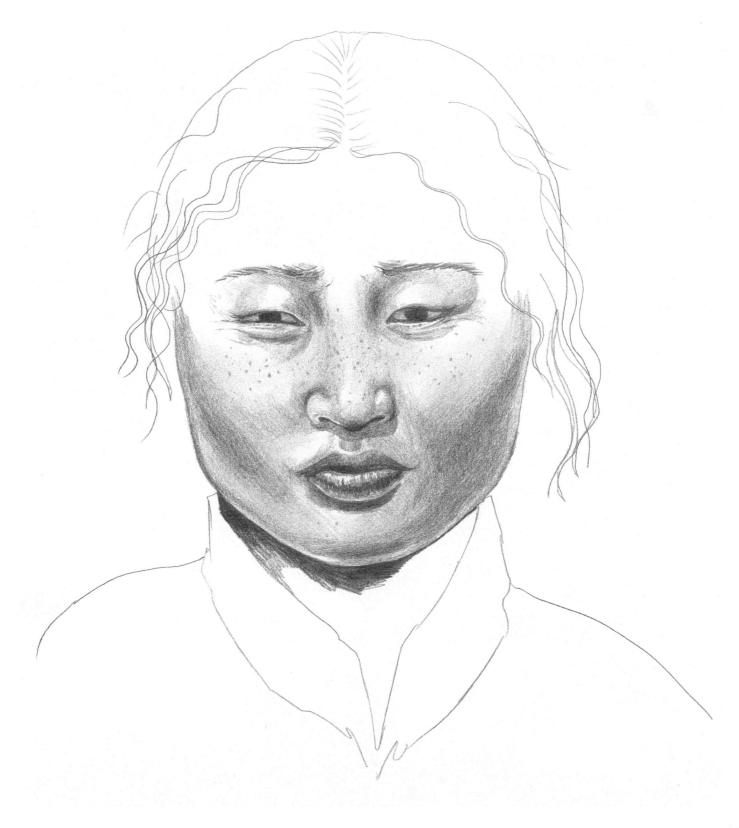

DETAILS OF OLDER SKIN

Older skin is beautiful and can be created in a number of ways. It requires more mark making to capture its complexity.

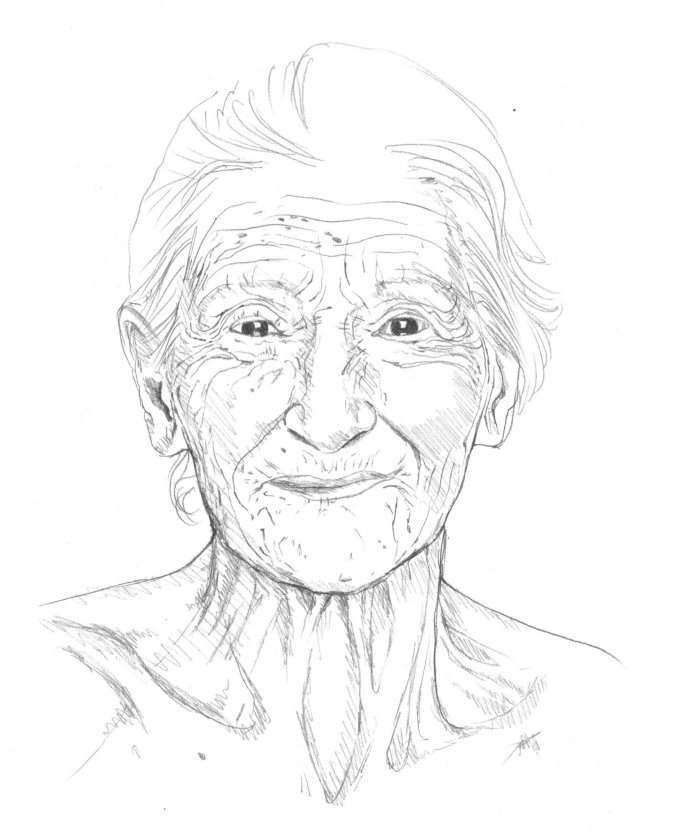

OLD AND YOUNG AND A SMALL BEETLE

In this example you can see an older hand and a younger hand with a small beetle crawling across it. The different textures of the skin and the beetle introduce a narrative into the image that is quite intimate and loving. For the older skin the creases and wrinkles have been drawn using variable line weight, cross hatching, hatching and stippling that complements the directions of the creases themselves. This has been layered with blended tone, with more textures on tone. Intense tonal shading has been added around the edges of the hand to emphasize where the hands meet.

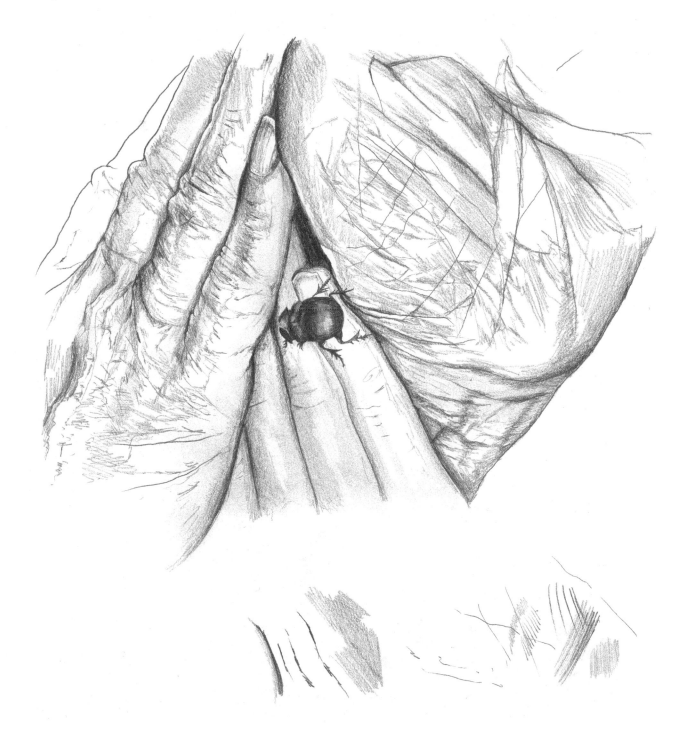

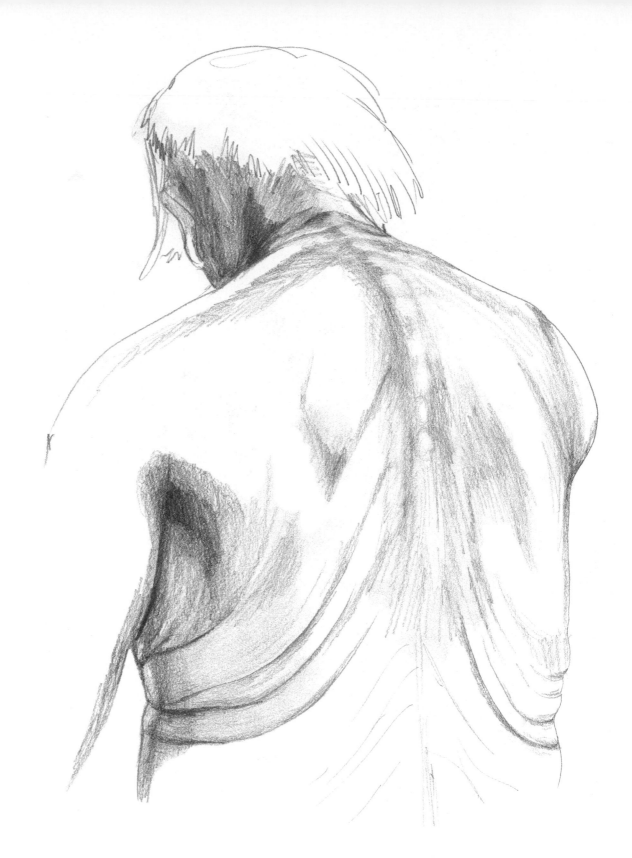

FOLDS

In this example we can see the spine: emphasizing bony protrusions and folds in the skin creates an expressive image of the figure. Skin varies greatly in its texture and quality; it can be perceived as a flowing veil or structure. Drawing in creases and folds is something to celebrate.

DETAILS AND THE EYES

In this example hatching combined with cross hatching and variable line weight has been used to create folds in the eyelids. Skin folds are wonderful to draw.

The eyeball itself will need extra shading to be added as the skin around the eye and the fact that the eye is held in place within the eye socket creates a lot of shadow and a lot of reflections.

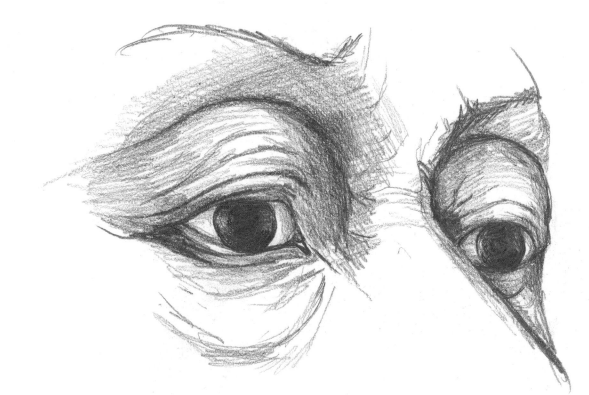

SCARS AND DETAIL

In this example hatching combined with cross hatching, slight stippling and blending in areas of more intense tone has been used.

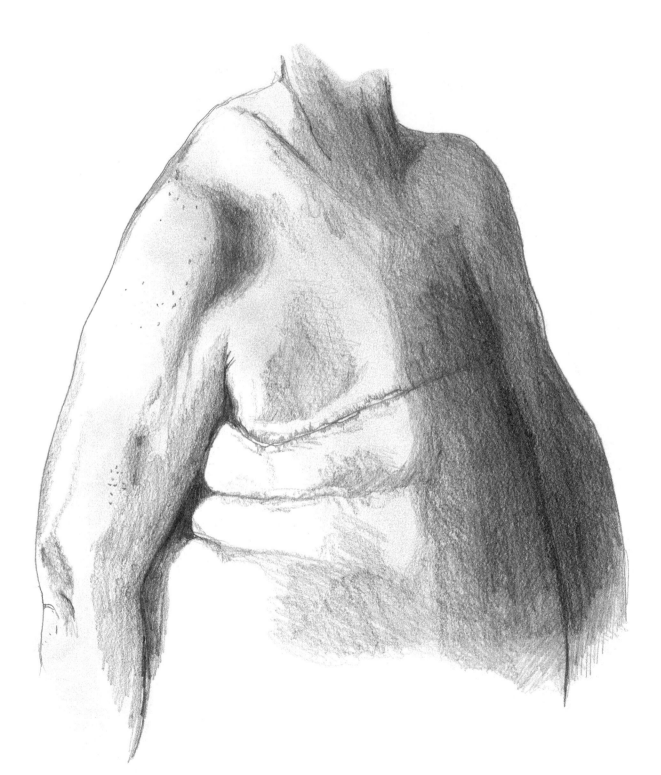

LIGHT, SHADOW AND TEXTURE

In these examples we see the torso of two figures. One is facing the viewer and the other is side on. You can see in the side-on drawing that illumination and reflection have been created using hatching, blending and a putty rubber.

SKIN TEXTURE AND STRETCH MARKS

In this example stretch marks of the skin have been drawn using an HB mechanical pencil. You could use a harder pencil if you prefer. The pattern created by the stretch marks was sketched out using light circular motion.

BODY HAIR

In this example leg hair has been drawn using mark making, dots and dashes.

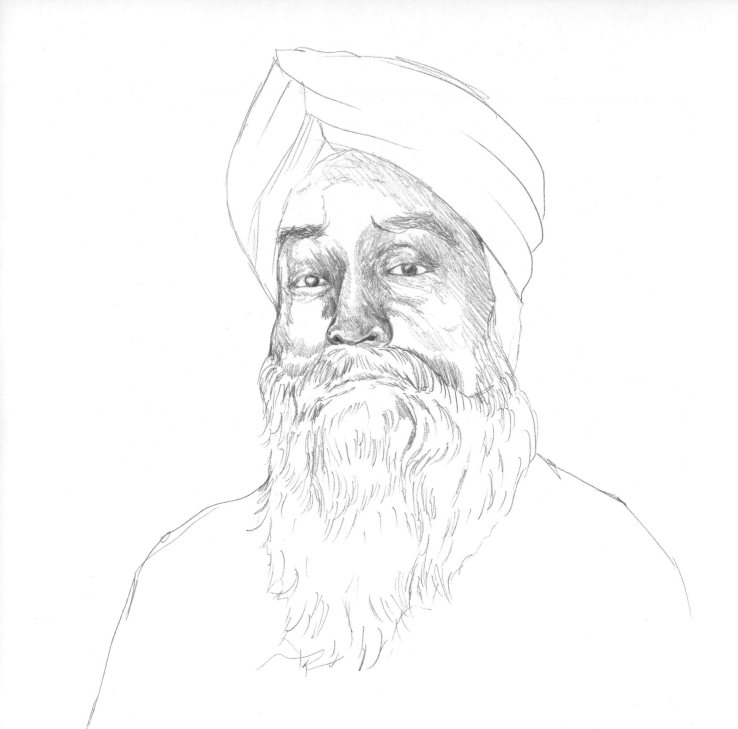

FACIAL HAIR

Dots and dashes can also be used in the sketching of facial hair.

Facial hair can be subtle. Try to observe the direction of
hair growth and ensure the mark making follows the grain
of the hair.

FACIAL AND BODY HAIR

In this example dots and dashes were used to capture the stubble on the face, shadows and hair on the chest.

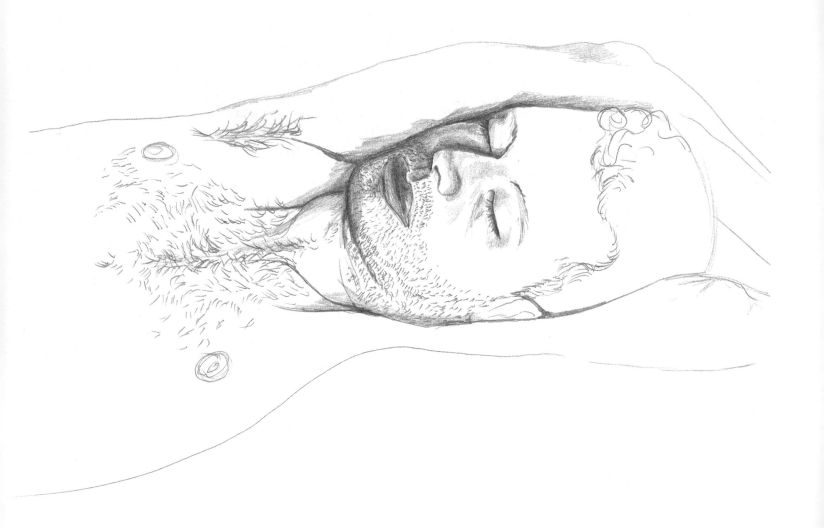

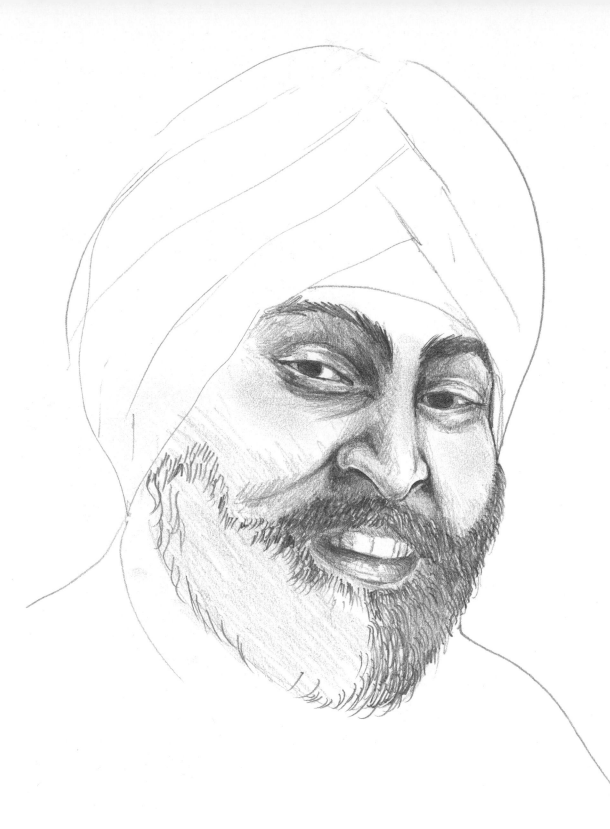

In this example we can see the use of dash-like marks on top of tonal hatching. This creates a sense of depth and shadow and light beneath the hairs. Using a thicker mark might be necessary for the stubble of beard hair as facial hair can be thicker than other kinds of body hair.

CREATING THE TEXTURE AND STYLE OF HAIR

Structure and texture are both very important when drawing hair. It might not be something you have time to focus on when a model is sitting for you but you can gradually focus on it in multiple sittings or combined with photographs.

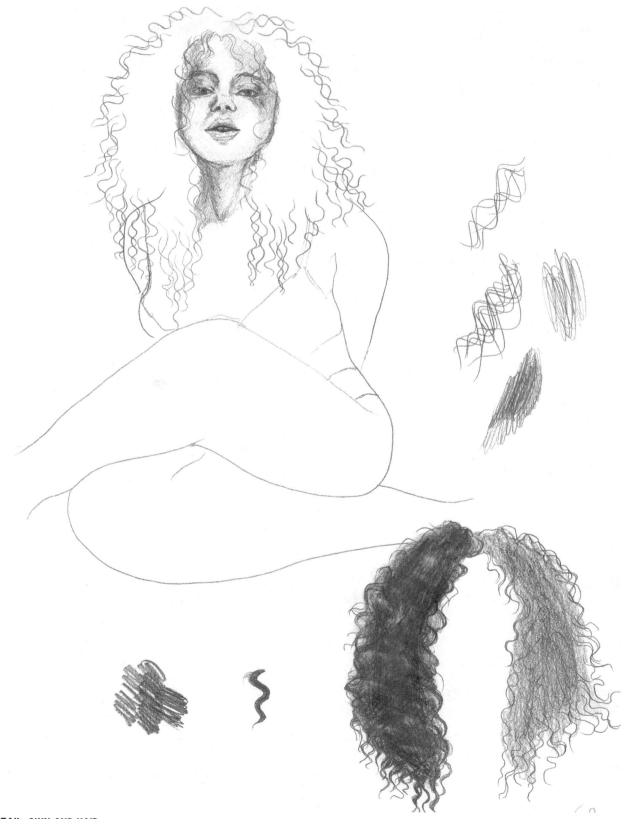

HAIR STEP BY STEP

The first stage in this drawing is to sketch out the shape of the hair followed by rough marks that complement the structure of the hair itself. As this is afro hair, the marks I have used include loose but small circular scribbles drawn with a wide stick of graphite to enable me to expand the area where the tone is.

This stage needs to be repeated and then smudged as if you are building up layers and layers of texture. In this drawing we can see some slightly larger circular scribbles and some more intense areas of tone. After this stage, a layer of more even tone needs to be applied to blend the shapes of the scribbles into a finer texture.

The last stage in drawing hair is always to look out for details and capture their shapes. Draw over the blended layers of tone and texture beneath.

BUILDING UP TEXTURE AND TONE ON HAIR

Whatever tonal layering you do, the final layer you add must closely resemble the textures you observe. It's a lot of fun to capture hair.

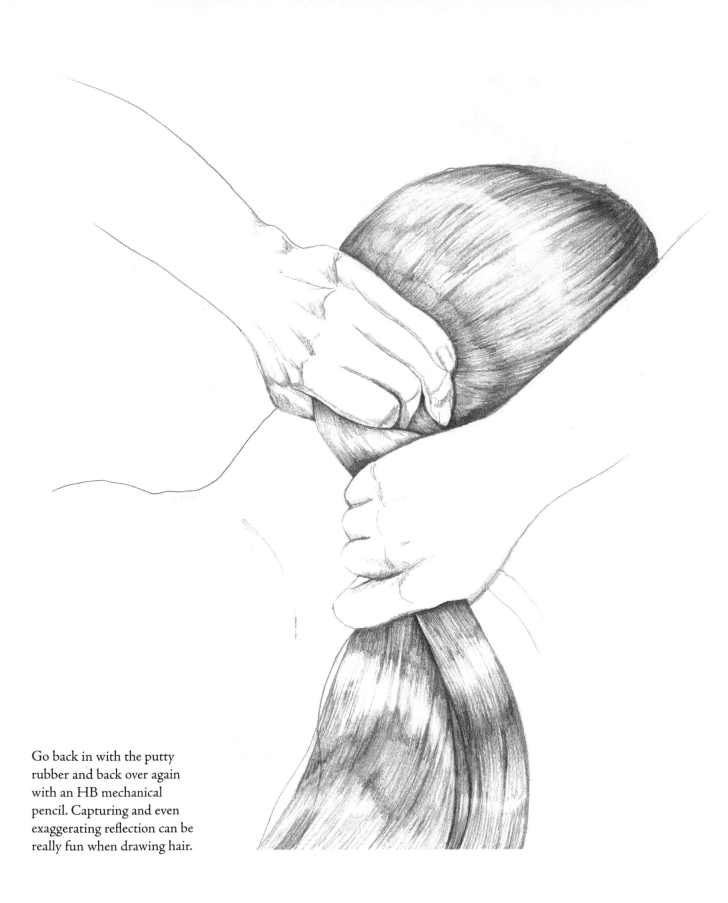

Go back in with the putty rubber and back over again with an HB mechanical pencil. Capturing and even exaggerating reflection can be really fun when drawing hair.

DRAWING BRAIDS

The structure of hair can be recreated using simple shapes. The braids (plaits) in this drawing have been drawn using long tapered shapes which were then divided in two using a fluid, curved line. Each half is then sectioned into small 's' shapes that create the form of each braided segment of hair. Using mark-making and tone, the tapered edge of each small shape is shaded so that there is a highlight in the middle of each braided segment. To complete the drawing, the outside of each long, tapered shape is framed by small hair shapes created with a mechanical HB pencil.

REFLECTION ON HAIR

In the next image, an outline of the section of hair that is reflecting light is sketched out. Mark making follows the direction and flow of the hair to create and build up the correct texture.

BUILDING UP TEXTURE AND TONE

In this example we see hatching changing direction and a putty rubber being used to create illuminated highlights. Layering of tone and texture was necessary in this drawing. Drawing flyaway hairs and groups of curls adds more texture to the drawing.

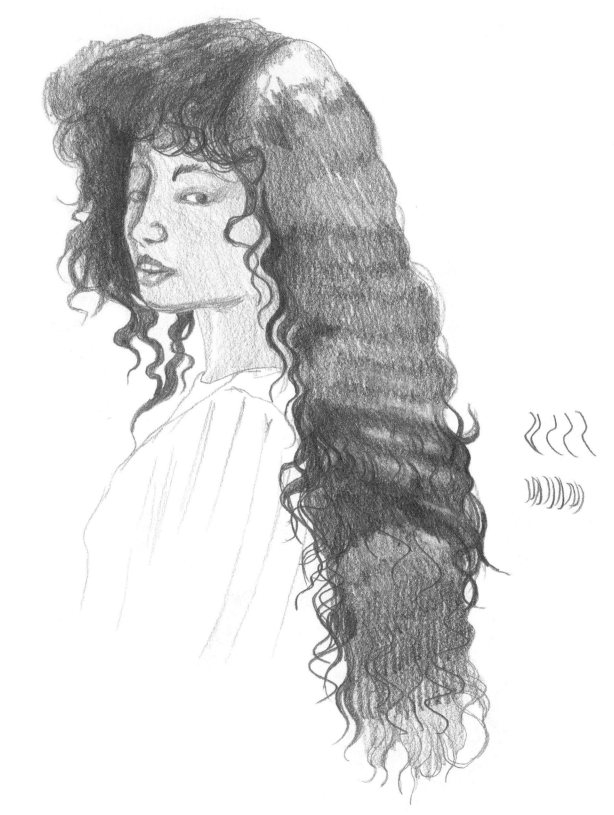

INDEX